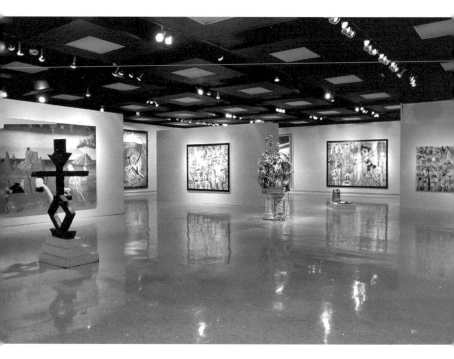

KENNY SCHARF

WITH ESSAYS BY
BARRY BLINDERMAN, GREGORY BOWEN,
BILL MCBRIDE, ANN MAGNUSON,
*AND **ROBERT FARRIS THOMPSON***

UNIVERSITY GALLERIES
ILLINOIS STATE UNIVERSITY
NORMAL, ILLINOIS
1998

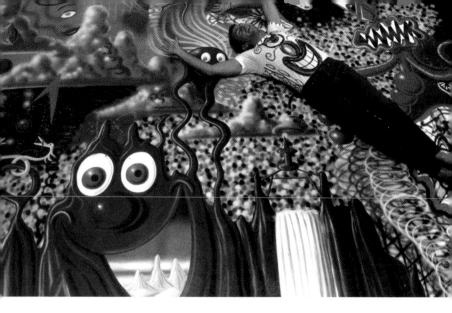

This book and the *Kenny Scharf: When Worlds Collide* exhibition (January 14-February 23, 1997) were generously supported by grants from the National Endowment for the Arts and the Illinois Arts Council, a state agency.

Design: Gregory Bowen, using QuarkXpress
Editor: Barry Blinderman, assisted by Jean Luther

ISBN 0-945558-26-0

**NATIONAL
ENDOWMENT
FOR THE ARTS**

Illinois
ARTS
Council
AN AGENCY OF
THE STATE OF ILLINOIS

This program is partially sponsored by a grant from the Illinois Arts Council

CONTENTS

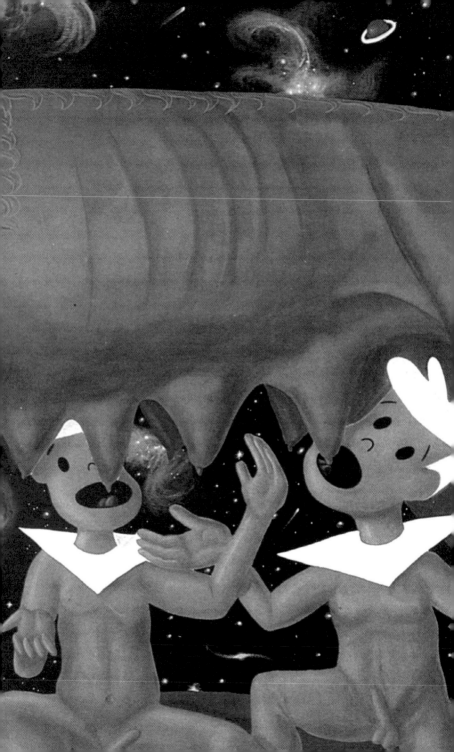

THE GHOST OF FUTURE PAST
BARRY BLINDERMAN

Kenny Scharf's art infuses pop icons, Homeric chimeras, and sinuous biomorphic forms with a symbolism reflecting electronic media's insistent grip on our most primal fantasies. One of the artist's earliest childhood memories is sitting inches away from the color TV set and staring at the screen until going into a hallucinatory state. A space-age baby suckled on television and weaned on Pop, he osmotically absorbed media images, sci-fi design, and past art styles.[1] The futuristic symbols of the sleek Sixties that permeated all levels of culture, particularly in the artist's native Los Angeles, left an indelible imprint on Scharf's nascent sensibilities. While escaping into a nineteen-inch Nirvana in his living room, he really believed he'd be going into space in no time at all.

The future as envisioned in the past, particularly technology's failure to deliver its vaunted World of Tomorrow, is a theme that lurks beneath the veil of optimism exuded by nearly all of Scharf's work. In videos he produced in 1980, while still a student at School of Visual Arts, his ambivalent fascination with relics from technology's postwar golden age is clearly evident. *Carousel of Progress* is a sci-fi romp starring Keith Haring, Ann Magnuson, John Sex, Scharf, and other art luminaries who were regulars at Club 57, a film and performance nightclub in the basement of an East Village Polish church. Part of this video was shot in Queens, where the actors performed a Felliniesque carnival dance around the colossal steel Unisphere sculpture from the 1964 World's Fair. Any baby boomer old enough to remember air-raid drills and basement fallout shelters with canned goods stacked to the ceiling can

appreciate the portentous element implicit in the idealism of Kennedy's "new frontier." Nevertheless, the radiation sickness plaguing the band of survivors in *Carousel* annoys the actors far less than the absence of TV broadcasting.[2] Scharf, facing the camera dead-on in a scene preceding the space launch, laments "we want to go to space because it's . . . it's not good here anymore."

Yes, perhaps "it" was only good on TV. And what better symbol for the nuclear family in the throes of the information age than the Jetsons? Beginning around 1981, inspired by the cartoony pictorial graffiti styles of Lee, Fab 5 Freddy, Futura 2000, Haze and other "writers," Scharf began spraypainting Jetsons tags on walls along the route from his studio at P.S. 1 in Long Island City to his East Village apartment. Sometimes reaching mural proportions, these works featured Judy Jetson heads, Elroys with bug bodies, or two-headed Rosie the Robot mandalas, along with elements that would become longterm staples in the artist's iconography: space towers, puffy thunderhead clouds, galactic spirals, and illusionistically rendered orbs.

At the same time, he painted landscapes containing altered or metamorphosed Jetsons and Flintstones characters on small pre-fab canvases. An intriguing example is *Statue della Judy*, 1982, in which the ponytailed Jetson teen is shown naked on a pedestal, voluptuously straddling a vine, holding an atomic globe in one hand and a clump of grapes in the other. Attended on either side by a mirror-imaged Wilma Flintstone as a spiral-bodied sphinx, Judy paradoxically represents both an Apollonian muse of Science and a Dionysian priestess. The nonchalant convolution of time—Flintstones : past,

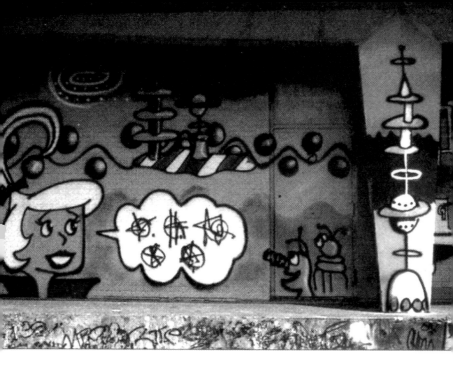

STREET MURAL, NEW YORK CITY, 1981

Jetsons : future—is an early instance of a "future primeval" theme that was to appear steadily in the artist's work to come.[3] In addition, an absurd Pygmalion effect is at work here: Except for the recent movie de-animation of *The Flintstones*, we've only encountered these characters as cartoons. Scharf memorializes them as fictional aberrations "in the round" of images that have existed only two-dimensionally. Portraying Judy as disrobed and full-breasted adds yet another level of disjunctiveness to this little painting, which alludes to the idea of history as a fabrication promoted in large part by painted and sculpted representations. From this point onward, any socially engrained dualistic thinking became

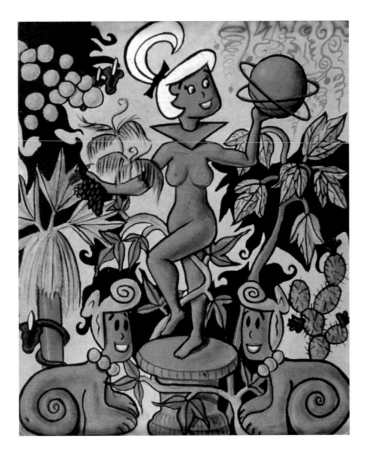

STATUE DELLA JUDY, 1982
ACRYLIC ON CANVAS
12 x 10 INCHES

12

fair game for Scharf. Popular relativistic analogies, e.g. the infinitely small bearing the same structure as the infinitely vast, or the distant future resembling the ancient past, were absorbed into his quickly evolving brew of imagery.

It is not surprising that half-human, half-animal creatures inspired by Greek and Egyptian mythology, as well as references to curious overlaps between Christian and Classical imagery as depicted in Italian Renaissance painting, should have emerged in Scharf's cartoon pantheon at this time. After all, cartoon characters give children, adolescents, and even some adults tangible contemporary access to the kinds of heroes and villains found in both classical literature and the Bible. Just as we find more than a trace of the heaven-sent yet vulnerable man-god, Jesus, in the dual-ego Superman, or the fleet-footed Mercury in The Flash, George Jetson and Fred Flintstone revive the character of the less heroic "everyman" found in medieval morality plays. Whereas Superman scenarios typically involve the superhero's foiling of diabolical schemes by evil scientists or aliens plotting to take over the earth, in the Jetsons universe, the greatest threat is George losing his job at Spacely Sprockets or Jane spending too much cash at the Space Shopping Center. (This was even before the "mall" was invented.) Cartoons also bring most people about as close as they'll get to an appreciation of art. The animation is all done by bona fide artists, who often delight in slipping in references to art masterpieces.

In a trio of large-scaled paintings he made in 1982, with imagery gathered from live encounters with European art treasures, Scharf painted both Greco-Roman and Judeo-Christian scenes invaded by characters lifted unabashedly from

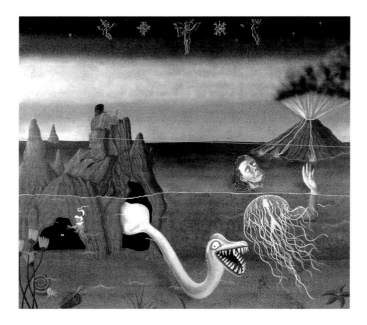

In Ecstasy, 1982
ACRYLIC ON CANVAS
89 x 107 INCHES

Hanna-Barbera. *In Ecstasy* teleports the kneeling Jesus from Giovanni Bellini's *Agony in the Garden* to an electric-hued scene featuring an underwater cave, a yellow sea monster, a floating head and hand, an erupting volcano, and various sea creatures on the pink ocean floor. The head, visually "decapitated" by the body's immersion in the water, references both the baptismal and martyred aspects of St. John. Blue-skinned, as in depictions of the Hindu god Krishna, the six-fingered Christ prays to chalice-bearing Elroy Jetson in the sky—a wispy specter as in the Bellini, except that he is accompanied by the additional "holy ghosts" Pebbles Flintstone and Bamm-Bamm Rubble.

Elroy and Leroy situates a naked Elroy Jetson and his fictional twin on a purple asteroid, in the place of Romulus and Remus in the famous Etruscan bronze.[4] Sporting collars, space beanies and pubescent erections, the twins' arousal from the teats of a stoned blue she-wolf heralds our turn-on to electronic media's displacement of religion as myth bearer and trance inducer.

In *St. Elroy Slaying the Dragon*, Elroy Jetson fills in for St. George in Paulo Uccello's 15th century work, freeing his sister Judy, who has metamorphosed into a butterfly. *St. Elroy* is Scharf's first large painting to feature a half-cartoon, half-animal hybrid. Uccello had already thrown a wrench in the Christian morality issue by providing a rich framework for sexual innuendo: the big cave with its black, ribbed interior, serving as backdrop to both the maiden and the dragon, and the phallic spear, plunged into the left eye of the dragon. Scharf's additions and transformations of images, along with his fluorescent candy colors, result in an outrageous allegory of teen lust and its fulfillment. Hilariously merging horse and

rider into a smirking centaur in overalls, Scharf runs amok through art history, mythology, and interpretations of the classics by Freud. This is no mere random image scavenging, or art-about-art. Scharf didn't just answer the poet Baudelaire's call for the artist to pick freely from the "forest of symbols that observe him with familiar glances;" he went in there with a chainsaw.

All three of the paintings cited above contain animal imagery, and there is something unmistakably Oedipal/incestuous about the latter two: St. Elroy puts out one of the dragon's eyes (Oedipal blinding) to free his sister. The spear and spurting volcano may be construed as symbols of Scharf's adolescent takeover of the reigning "art dragon." Similarly, a doubly incestuous relationship is the focus of Elroy and Leroy: Are the twins getting sexually excited by their bestial nursing or by each other? In Roman myth, the brothers—orphaned sons of a mortal and Mars—were raised by a she-wolf and together founded Rome. Romulus then killed Remus, thus providing an element of latent violence to Scharf's painting that parallels the Georgian dragonslaying in *St. Elroy*.

In contrast to Warhol's and Lichtenstein's early 1960s appropriations of cartoon imagery, where excessive manipulation of found mass-media material was unthinkable, Scharf's work celebrated the arrival of a more primal and protean content in imagemaking. Notwithstanding the Pop artists' elevation of crass media vernacular, Scharf's acrid color schemes, crude technique and outlandish juxtapositions seemed at first as vulgar and unaesthetic as could be. He believed that his generation was living Pop, not observing it—that the cathode-ray tube had bombarded the collective unconscious with new archetypes to be combined and transformed at will.

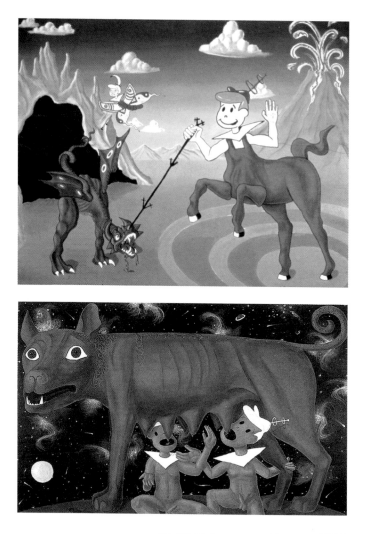

St. Elroy Slaying the Dragon, 1982
ACRYLIC ON CANVAS
48 x 54 INCHES

Elroy and Leroy, 1982
ACRYLIC ON CANVAS
60 x 96

17

Chrome on the range

KENNY SCHARF

TIRED of the same old appliances? Pop a little zip into your life and treat your every-day electrical appliances to Van Chrome's functional home-improvement idea: customizing!

What is Van Chrome's customizing? Well, it's an incredible way to enhance your life and make ordinary objects look meaningful and fulfilling by adding Van's secret physical materials to the surfaces.

Here are just a few examples of what Van can do for you.

Bored with television? Hire Van to make your TV experience incredible. With Van Chrome's expertise, you'll have things to watch even if the set is turned off! Styles include everything from mind-blowing psychedelic patterns to fantasy-fulfilling space cities.

Personally in touch with their appliances, Van's customers grow to name and love their new friends. Take Kelly Garret, for example. Before she met Van she was just a Hoover; now she not only vacuums but goes for walks in the city, too. This pretty girl is a real head-turner, and you'll like the security of having a pet around the house.

Say hi to Cheeky! She's a modern pet and a hair dryer, all in one. Pets can be dirty and a nuisance. A pet like Cheeky is a clean, func-

tional, fun household item. Besides being pretty and good company, she'll dry your hair efficiently. What a friend!

Everyday experiences don't have to be ordinary. Why not convert your routine vacuuming, TV viewing, radio listening, hair drying, air conditioning, telephoning, record playing, blending — every electrical task! — into something magical, spaced out, or just plain fun? Any appliance can be transformed.

Best of all, when your electrical energy runs out, you don't have to throw your appliances away; they become art objects reminiscent of the prosperous electrical age we've come to know and love.

Van Chrome's new process dissolves the sterile boundaries between man and machine created over the years by predictable esthetics geared to the masses. Up with appliance liberation!

Van Chrome will customize anything and everything — appliances, bicycles, eyeglasses, bodies, closets, cars, coffee shops. Just ask him and he'll do it. Call (212) 677-4437.

For all you interested readers who reside outside the New York area, don't fret: you can send away for the Van Chrome customizing do-it-yourself kit! Comes complete with the necessary ingredients, plus a marvelous fully illustrated brochure full of Van ideas you can do yourself. Don't wait. Customize now!

Van Chrome TV

"Kelly Garrett"

"Cheeky"

PHOTOS: TSENG KWONG CHI

"VAN CHROME CUSTOMIZED APPLIANCES," SOHO NEWS, JULY 1981

The fact that the material is re-used is, in truth, the paradox. It ceases to be waste. —Robert Rauschenberg, 1961

Collage, with or without the glue, is one of a few overarching tendencies characterizing twentieth century art and design. A lineage can be traced connecting Picasso's bits of newspaper and faux wood grain, Duchamp's mustachioed Mona Lisa, Joseph Cornell's dreamy boxes, Rauschenberg's multilayered silkscreens and combines, and computer cut-and-paste images and texts. Since he began exhibiting his artwork, Scharf has been a voracious recycler—of past artistic and decorative styles, of 60s and 70s Saturday morning cartoons,

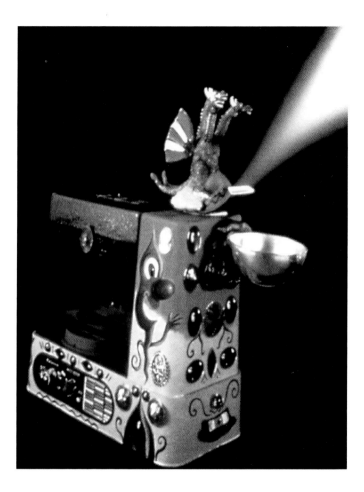

HUMIDO MOISTESSA, 1986
ACRYLIC AND FOUND OBJECTS ON HUMIDIFIER

of found objects and discarded appliances, and of his own invented characters. He is just not content to leave well enough alone, and his idiosyncratic use of assemblage and mix-and-match imagery is a salient factor in his work to this day.

[Scharf] brings painting to objects like Robert Rauschenberg brought objects to painting. It's still Rauschenberg's line between art and life; Scharf is just working the other side of it.[5]

As his hot glue-gunslinging alias, Van Chrome, Scharf "customized" hundreds of telephones, TVs, boom boxes, vacuum cleaners and other utilitarian objects with painted patterns and cartoon headshots, plastic dinosaurs, costume jewelry, and vacuum tubes. Rather than creating abstract assemblages from industrial objects, like Rauschenberg or Arman, Scharf aimed to enhance the user's appreciation of a given appliance through the addition of paint and other manufactured objects. Attempting to reestablish art's ancient connection to everyday life, he set about "fetishizing" neutral-looking household appliances so that people could engage in mundane activities with style.

Although he drew from relatively the same reservoir of salvage and baubles to decorate these ritualistic leisure and work appliances (in the case of telephone, it can be either), at times Scharf's choices were anything but arbitrary. In some of these kitsch-laden objects we see indications of the artist's love of sight gag. For example, a three-headed toy dragon perched on top of a humidifier is reminiscent of Norse ship ornaments, and also provides the modern steam-spewing device with a smoke-breathing mythical counterpart. We are reminded that technology, like art, has a long history of imitating not only nature, but the stuff of which dreams are made.

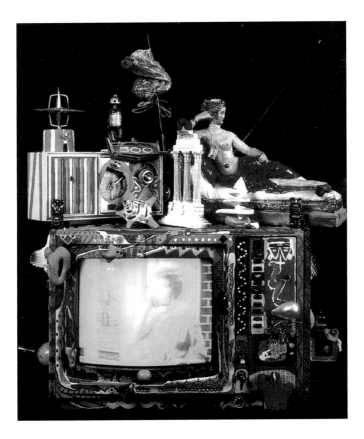

VAN CHROME TELEVISION, 1981-3
ACRYLIC AND FOUND OBJECTS ON
10-INCH SONY TRINITRON

21

In *Van Chrome Television*, a miniature replica of Canova's *Pauline Borghese as Venus* is among the objects sitting on top of a Sony Trinitron. Napoleon's half-naked sister, lounging on a Roman sofa, becomes the perfect antecedent for the modern decadent—the soap opera watcher. Beholding a Jetsons-decorated cigarette machine or a 70s boombox with glitzy squiggles and plastic jewels gives the viewer a feeling of archaeological finding—even without the artist's embellishments, the objects themselves are artifacts of programmed obsolescence. With the rampant digitization of consumer electronics, there's hardly such a thing as a dial or a toggle switch anymore. And Elroy Jetson, for that matter, seems like a character from some future long past.

Although Scharf still customizes, his knack for visual punning with "period" objects was for the most part channeled in the early 1990s into paintings in which his grinning plasmoid blobs and illusionistic globules hover over dense grounds of photosilkscreened 50s and 60s newspaper/magazine images and texts—themselves applied over drips and splats alluding to Abstract Expressionism. Media-graffiti replace the earlier spraycan swirls in paintings like *Junglerama*, in which headlines addressing deforestation and the depletion of the ozone layer intermingle with silkscreened images of weed killers. As if to offset the didacticism with characteristic humor, the artist encased many of these works in elaborate vinyl, aluminum, or astroturf frames referring to the incorrigible virus of suburbia.

In *Biorama*, a 17-foot wide painting done in 1991, a Rohrschach-like near-doubling of silkscreened 60s ad imagery—cars, tires, jets, a Kodak camera girl—surrounds a "construct" of a woman whose body is a jet, and whose 60s hairdo is "crowned" by a

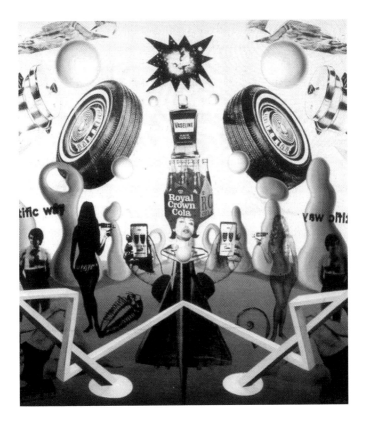

BIORAMA, (DETAIL) 1991
OIL AND ACRYLIC ON CANVAS
91 x 205 INCHES

bottle of Vaseline hair tonic perched upon a six-pack of Royal Crown Cola. Her iconic pose identifies her with snake-wielding Minoan goddess figures, especially since her oversized collaged hands hold TV remote control units—the technological equivalent of snake magic. The silkscreens are applied symmetrically throughout, over a hand-painted pink backdrop resembling Stonehenge rendered in molten lava lamp wax. As if this were not enough, the artist has added a handpainted layer *over* the silkscreens, consisting mostly of yellow globes radiating from the TV goddess, perversely mimicking the vanishing point on the similarly posed Christ figure in Leonardo's *Last Supper*.

Kenny Scharf has directed his fertile imagination and tireless working style toward exercising the limits—pre-stretched by Duchamp, Rauschenberg and Warhol—of acceptability in late 20th century art. His highly charged emblems have withstood the crossfire of the turbulent 1980s arts scene, restlessly evolving, recombining, and wriggling their way into the 21st century. As in the case of his peer Keith Haring, the wide-range popularity and mass-media attention he received by the mid-80s also deterred objective critical analysis of his work. Facile categories such as "graffiti" and "cartoon art" were carelessly applied, with serious criticism reserved for cool media artists who had long since exorcised any trace of originality or gesture from their work. It is baffling to me that Scharf is regarded by many critics as retro or a lowbrow populist. The ambivalent fusion of high art and cartoon, technological aspiration and ecological devastation, myth and mass-media, and hedonism and spirituality in his work is only beginning to be examined.

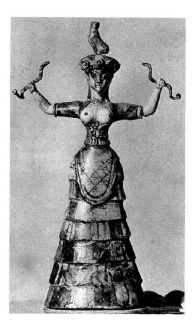

1. Scharf was born in 1958, only months after the first U.S. satellite was launched into orbit.

2. The radiation sickness tragically foreshadows AIDS, which halved this crew a decade later.

3. *The Jetsons* was a spinoff on *The Flintstones*, itself based ostensibly on *The Honeymooners*.

4. The twin figures were actually a 16th century add-on to this ca. 500 B.C. sculpture, contributing yet another layer of historical displacement to Scharf's painting.

5. Gerald Marzorati, "Kenny Scharf's Fun House Big Bang," *ARTnews*, September 1985.

OBSIDIAN BARBERA DEATH, 1983
OIL AND SPRAYPAINT ON CANVAS
48 x 36 INCHES

Mushrooms + television childhood = Pop Surrealism.

Religion is strong . Mandalas are used in all religions.

they all have a center. They can hypnotically bring you to a
her level. Early Mandalas were simple. Simple symbolic shapes.

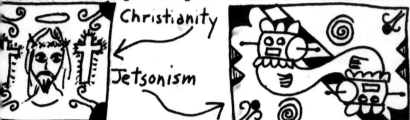

 spiral is easily understood as a means to other levels (worlds).
r example: the tornado, the bathtub drain spiral where entering

 take place (air through water).Galaxies are spirals. Suction-
ck holes? Spirals are universal in space, in nature and
culture. second degree religions include mandalas with icons.

Christianity

Jetsonism

 importance of religion in art stems from the increasingly
eatening situation of nuclear catastrophe. Will I be alright
n I'm dead? Well, hopefully. If you believe in being good
 will lift your arms up the mushroom cloud, through a spiral
"heaven".

aven being the universal oneness with time equals nature equals
. God equals hydrogen atoms because they are the only things
ated from nothing. Hydrogen God is the creator: sun, planets,
th, man.The sun being hydrogen, fusing to helium as an after
oduct. Man plays god by using atoms,destroying himself in the
ocess-nuclear catastrophe.

Kenny Scharf

tsonism is Nirvana.

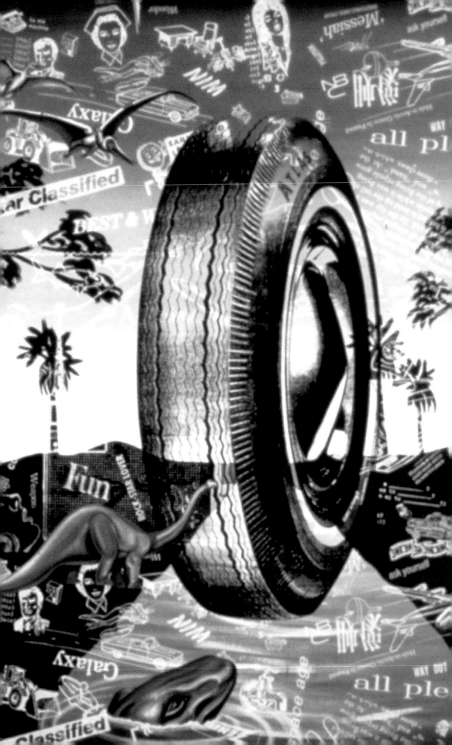

THE WAY WE WERE
ANN MAGNUSON

Kenny brewed the magic tea in his kitchen on Ninth Street. Not the apartment down below where he lived when I first met him, when he did his show at Fiorucci with the paintings of the Fifties glamourpuss housewife with the jet engine spike heels that impressed me so much. But up on the fourth floor where we used to gather to watch "All My Children" and listen to the latest David Bowie record. Bowie and television were our common religion. And psychedelia, in all its manifestations.

There were only a handful of groovy people living in Alphabet City during those halycon days. Richard Hell could frequently be seen strutting his foxy art rock stuff on St. Mark's Place and once in a while you'd be lucky enough to catch a New York Doll or two. But we were the freshmen on the campus. Upstarts. Jean-Michel Basquiat was just plain Samo then, Keith Haring was getting heckled at poetry readings, Madonna was in Paris doing Pat Benatar impressions and we all thought Studio 54 should be firebombed.

No one ventured north of Fourteenth Street since our Downtown world was complete, if slightly hazardous. Drew Straub, who with Kenny was one half of the world's most obnoxious singing duo, the Batusi Brothers, had to wear a Mike Nesmith wool cap out because the teenagers would beat him up on account of his bright blue hair. Kind of hard to believe now that everyone in this MTVietnamized universe is "alternative." But I preferred the East Village when it was as it

was—quiet as a Budapest suburb, save for the secret society of artists and assorted deviants that found sanctuary on the banks of the East River.

That particular night, Kenny and I figured we'd drink the tea in Manhattan then make our way to Kenny's studio at P.S. 1 in Long Island City, where we planned an all night communion with the Goddess of Day-Glo in one of Kenny's many customized closets. Tracers from the neon lights danced in front of our eyes before we even hit the subway.

Once down in the depths of the stinking New York underground, the full impact of the urban-blighted hell we had voluntarily moved into hit like a blast of week-old urine rising from the smoking Third Rail. Dante could not have envisioned a more punishing inner circle of Hades. I felt buried alive in a concrete and metal tomb and wondered, why had I forsaken the comfortable confines of suburbia? And why on earth did Kenny leave the sunny, cellophane palm-lined streets of the San Fernando Valley? Because, fueled by myths from bohemians past, we gleefully moved to the Lower East Side to costar in reruns of Andy Warhol's leftover dreams. But at that moment, as we sat aboard the "F" train, Kenny was talking me out of a bummer, assuring me that Long Island City was the next stop and beyond that, paradise.

The stars twinkled brighter on the other side of the river but not nearly as bright as those Kenny had painted on his studio ceiling. Jimi Hendrix launched us into hyperspace and before long the resemblance between Kenny and Captain Kirk could no longer be ignored. Like radioactive refuse from our Pop-drenched upbringing, the candy-colored knickknacks and

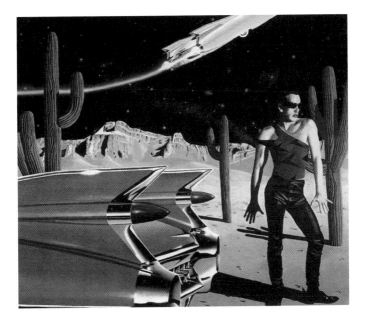

phosphorescent gewgaws Kenny had strung from tiny threads collided with the Christmas tinsel which hung like Spanish moss around the black-light lit room. I stared like a wide-eyed teen at a swinging Calderesque mobile Kenny had fashioned out of pink plastic tampon applicators we found washed up on Rockaway Beach. I imagined a Hydra emerging from the tendrils of a long black wig we called Jimbo in honor of his Morrisonness. A prop for one of my performances, we had taken it with us to Italy where we took turns donning it like papal vestments while posing atop the ruins of Rome. Now we were in the ruins of our own history and we couldn't stop laughing. Deconstructing breakfast cereal and deifying brand names, Kenny's alter ego, Van Chrome, took over the pulpit and the artist's studio became our church.

Remember the sequence in *Mary Poppins* where Julie Andrews and the kids jump into the chalk painting that chimneysweep Dick Van Dyke had drawn on the sidewalk? So inspired was I after that movie that when I got home I did my own chalk painting, said a prayer and jumped on it, hoping to be transported. Instead, my slate broke in two. That was the saddest moment in my life–realizing that Disney movie magic was bullshit.

But that tragedy had no place in this uncharted terrain known as Van Chrome Land. Because as I stared into the blue spiral he had painted on the ceiling, I felt myself being lifted up into its soft, chewy center, through the roof and up over the old brick school, rising higher and higher until I hovered over that magical circus of an island we call Manhattan.

"The fun's inside," Van declared. He flashed his Elroy Jetson smile as he opened the passenger door to the *Suprema Ultima*

Deluxa—the Van Chrome customized Cadillac he had so deftly balanced on the needle of the Chrysler building.

I grabbed hold of the nearest free cloud and climbed aboard America's original gas guzzler, which had been so stylishly refurbished in rhinestones and fake fur. The car was a triumph of jet-age design that gives you an astounding five miles per gallon. But, oh what five miles they are! Built for speed, velocity and rapid eye movement, the *Suprema Ultima Deluxa* was our one-way ticket to nirvana. Why, under that cosmic hood is an engine that runs like a dream! A dream powered by imagination. Imagination that has mutated itself through time, since the dawn of man, when dinosaurs ruled Earth. And that's where we are headed.

"Just leave the driving to Van," said the man with the tan. "He knows the way." And so he did as he set the Way Back Machine to way, WAY out! And there we went, back in time–from the gooey depths of the primordial ooze to the sacred quagmire of the La Brea Tar Pits. Ahead in time—to the artists colony on Mars and the Scharf-colored beaches of Eurotrashed Miami. Then back to the near present, where we celebrated Carnival in the Brazilian rain forest and bathed in Cristal champagne at Mr. Chow's in Beverly Hills. Yes folks, it was a wild time whenever any of us grabbed onto Kenny's coattails and hitched a ride on his art star that sped across the galaxy.

Ah, the good ol' daze. Not a fashion, but a feeling. Hard to describe, but something not unlike great sex. Something beyond the glamour of sordid theme parties at after-hours nightclubs or star-studded media-packed openings at blue-chip galleries. We were a movable feast of friends grooving in a

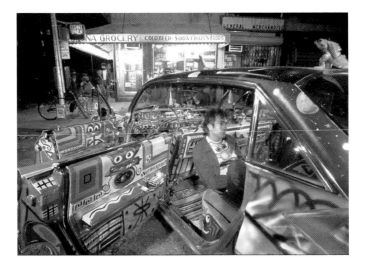

group mind and digging the scene in swirls and spirals, plugged into the many channels of being and communicating the ultimate philosophy of Grooviness on network, pay-per-view and, more importantly, public access cable.

Forget about Expressionism. Forget about Impressionism. Forget about Realistic Video Pluralism. It's not quite Surrealism. It's definitely not Cubism. And thank God it's not Streamlined Nihilistic Minimalism. For it isn't an "ism" at all. It's an "is-ness." There's no business like show business and this is the production number you've been waiting for. Art for

the end of the millennium: the *fin-de*-recycle. *Fin*-ism. Like the fins on a customized, cosmic Cadillac. Or the final frame of a French film. Full-finned phantasmagoric finicky fun. Finiculi. Finicula. Far fucking out!

But before we arrive at our final destination—where that bright light shines at the end of the tunnel, where our dearly departed loved ones who have died before their time are reaching out to touch us and say hello again—let us take one more spin around the town on Van Chrome Airways. He'll take you up, he'll take you down, he'll plant your feet back on the ground. He might even introduce you to Timothy Leary, who isn't dead but living on the moon sucking on nitrous oxide balloons.

Though it's often hard to recall the details, take a seat. The bigger picture, stretched wide across the canvas, will leave you exhausted, yet complete. I can see the dawn's early light is peaking through the blinds now and like all beautiful young vampires who outlive their peers, it's time to move on.

And so, now we conclude our broadcast day. Please extinguish all smoking materials, bring your seats to an upright and locked position and check your overhead luggage compartments for any childhood memories you may have brought on board. May I say, on behalf of the entire crew, that though we've only scratched the surface, it's been a pleasure servicing you and for those of you continuing on, enjoy the trip.

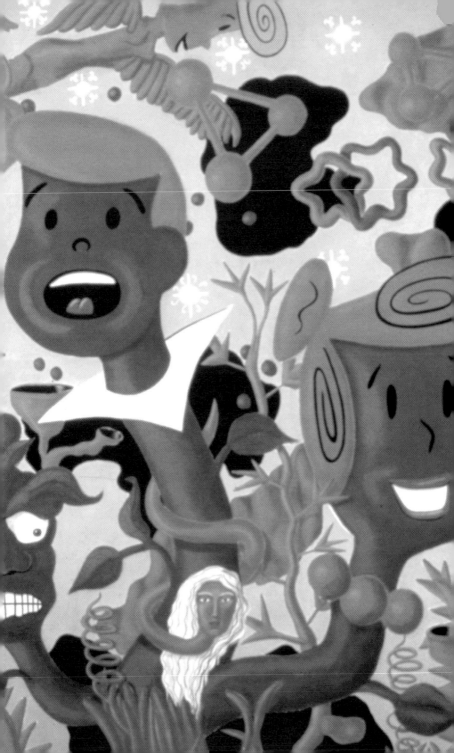

THE THOUSAND CLOWNS OF
KENNY SCHARF
ROBERT FARRIS THOMPSON

If things aren't funny then they are
just exactly what they are.

You gotta own your own day, each one,
and *name* it, or else the years go by.

—lines spoken by Jason Robards in *A Thousand Clowns*, 1966.

A clown's round nose and jester-like action light up the art of
Kenny Scharf. Overripe colors, stolen from candy, animate
figures adapted from the 'toons of TV. Dino from the
Flintstones, and Elroy Jetson meet landscapes from Dalí and
strange forest tendrils, arabesques gone mad. Recalling
Robards' marvelous jestering in *A Thousand Clowns*, Scharf
has elaborated an art full of pratfalls and ironies. With this art
unique to his mind and humor, he works with the future or
more precisely what we think will be futures, since no one
really knows time. Millenium is nigh and we humans are still
essentially anthropoid apes trying to live like termites. The
problem becomes acute.

But refusal-to-suffer is the byword of Scharf's painting. To put
things simply, he makes art with a sense of humor. It is coded
in the mixture of high-tech and sci-fi, rainforests and
dinosaurs, ball-like clown noses and outer space, dark and
star-filled, and waiting. If this is fun, there is hard work behind
it: Scharf painting overtime, good-naturedly responding to
inevitable interruptions—phone, friends, gallery owners, col-
lectors, wife, children—while he makes his art happen in
New York and Miami.

Scharf will name one day, for instance, by pasting toy dinosaurs and baubles on a television set, subverting the icon of commerce and advertising. He'll do this while at the same time receiving a scholar from a distant town, not missing a beat, gluing the objects on the edges of the set, giving person and objects equal time.

Humor and patience guard a riotous style. It takes its cue from growth curves and tendrils, berries and leaves. Scharf sees plants not as inert clusters of green, but as co-presences, allies, the quiet oxygen-makers, worthy of tenderness. He follows that love into ultimate chlorophyll, the realm of the rainforest. Witness: *The Jungle* (1982), *Jungle Juice* (1984), *Juicy Jungle* (1983-84), *Junguloony* (1986), *Jungle Times* (1991), *Junglarama* (1992), *Wetlands* (1993) and *Humidungle* (1996). These paintings are meant as love letters to a wet, organic, wild-leafed sprawl. "There is no place more alive than the jungle," Scharf said recently in Miami. "The jungles of Asia, Africa and South America guard our future. Without them we die."

And so, in *Humidungle*, he draws a tree that is also a sentinel. He paints a smile on its trunk. He gives it vision with a single eye. Thus humorously enlivened, cartoon style, with out-stretched branches becoming arms, the tree supports a world of vinous, twisting shapes: "growth, things evolving, the face of organic nature." Lost in tangled wildness, an imaginary garden is peopled with ideals: contrasts to the sterile lawns of sub-urban America. The wetness of the forest, what is more, rubs out memories of dryness and brush fires in southern California, which Scharf fled eighteen years ago.

Scharf takes his faith in the organic to levels literally cosmic. Out there, somewhere, he is sure, beyond the planet Saturn, beyond our galaxy, there is atmosphere, there is water, and a

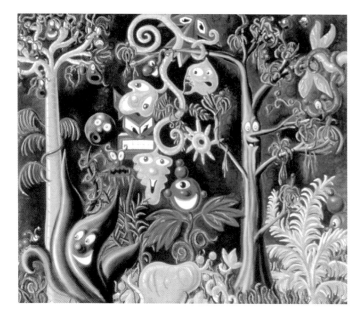

lushness of forests primeval. This he suggests in a strange recent sculpture, *Cosmiganic* (1996). He traces in space circles and curves, vines and trunks of polished metal, honoring nature in the medium of the heroic. Ever the confident rapporteur of fantasy, Scharf causes a toadstool to emerge from the curve of the life forms. It rises beneath a planet ringed like Saturn.

Scharf's "jungle" pictures or "organic" sculptures are *plantings* as well as art. He nurtures the growth curves, turning them into drawing or sculpture. His soul must have been listening when Jackson Pollock referred to his art as "gardening the picture." In any event, the wild-style, free-form "gardening" that surrounds his house on an island between Miami and Miami Beach is a telling extension of the way he makes art. Scharf goes about Miami after a storm, tenderly rescuing a shoot of damaged cactus or saplings blown down and abandoned. He brings them home and resurrects them in soil and water, then lets them grow wild as they wish. The result is a jungle, his own private jungle, a riot of shadows and leaves. Strange purplish leaves near the windows of his kitchen and a strong phallic cactus lead the eye to a planet-like sphere in metal, hanging on a wire. This brings into being a living faux-surrealism, loosy, goosey, and down-to-earth. Gardening in its natural state, i.e. letting species run wild, relates to the way he composes key paintings like *Juicy Jungle* or, better, *When the Worlds Collide* (1984).

Whether gardening or painting, Scharf keeps on clowning. He is building a fallout shelter, girded with horseplay and covered in irony, to protect himself and others from the killjoys in the atmosphere. He wears in his paintings the red bulb nose of the circus jester. It is his signature and aspiration. For the role of the clown is recovery of innocence and play. Otherwise, as Jason Robards reminds us in the film that probed such truth, life is becoming an endless waiting in a dentist's office.

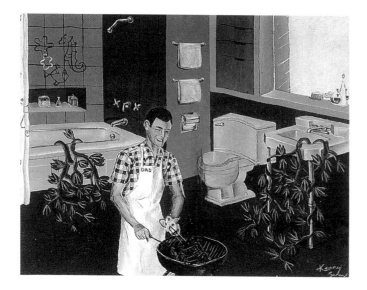

The concept of the clown allies with things earthy and organic, as revealed in William Willeford's *The Fool and His Scepter: A Study in Clowns and Jesters and Their Audiences*:

> A clown was originally a farm worker, hence a boor, hence—boors seeming funny to townsmen—a funny fellow, a buffoon. According to the O.E.D. cognate words in related languages (such as Dutch) convey such ideas as clod, log, block, stump.

If clowns were farmers, and Scharf loves both to laugh and to cultivate, then anciently caught in the whole jester concept is a validation of what he does with color, form and line.

Modernized motley might define his style, a Harlequin dress updated by techno-detritus. Nows sewn on thens.

The jestering taste for shock and joking animates an early work, *Barbara Simpson's New Kitchen*. Herein, a woman stands in smart grey attire, with toothpaste smile and starch-filled apron, presiding over a sterile kitchen. Suddenly a slimy dragon emerges from the disposal-all. Demented fear and loathing of life in suburbia, playfully enacted, carries over into another painting, *George Simpson's BBQ*. Dad, poor Dad, terrified of contamination by fallout in the atmosphere, does his barbecue in the bathroom, the bourgeois sanctum santorum. There he feels safe. But while the weenies roast in nauseating proximity to the toilet, behind him carnivorous plants are emerging from from metallic orifices. These salutary satires haunt the rest of his career. Tendrils and dinosaurs people his paintings, reappearing three-dimensionally when he customizes appliances. All trace back to the dragon in the kitchen and the liana in the bathroom.

Scharf is on the side of the jungle, of organic growth. He doesn't want to keep up with the Joneses, but with the weeds that defy their power mowers, with the birds that eat their pesticides for breakfast and survive. As a child of the sixties he says this often in TV lingo. *The Jungle* (1982), casts him in the role of Elroy, child of the bourgeois-futuristic TV family, the Jetsons. As Elroy/Kenny, he paints himself beyond the oceans to arrive at a never-never forest glen. He has captured exactly where he'd like to be, a child in the midst of wet, tactile green in whatever future, whatever past. And this makes the work a masterpiece of eighties bravado painting. He has salvaged the dream of his childhood (to travel *as* Elroy) and replanted it within a place and time where the air is gold and filled with ideograms. Able to read the runes which surround them, children turn into trees or vines, sharing the juices, celebrating the colors of a world of birth and renewal.

OOOZOLUTION, 1994
OIL ON CANVAS WITH WOOD FRAME
65 X 81 INCHES

So Scharf, at the end, becomes a gardener/clown/shaman. He likes to plant things in incongruous soil, the better to make them grow. This applies to his famous "customized" radios and cars and televisions. Working in this vein, Kenny takes on a special *nom de plume*, Van Chrome, when transforming, say, the sterile edges of a television set. He makes these edges sparkle with glued-on dinosaurs and bells and baubles. As Laura Watt, a young painter, said before a Scharf/Van Chrome composition, "it's refreshing to see a TV set creating chaos on the outside." Sim senhor! In the process, additive rhythms defining the way the textures transform the object, dinosaur-to-bauble-to-tower-to-figure, match, broadly, the incongruous upsurge, of persons, towers and landscape in some of his more remarkable paintings.

There is an early painting in which Scharf depicts God Himself as an old man with a white beard and green skin. God spreads His arms declaratively over a landscape framed with mountains borrowed from the flintlike hills that populate key works of Giotto. Between the mountains appears the sea. In the water a dragon frolics not far from two vessels with ideograph-like antennae borrowed from the futuristic settings of the Jetsons. But consider this point: the work is gardening as well as painting. Scharf rescues the appalled glee of a child before TV. He tenderly replants it in a landscape peopled with classy steals from Giotto and medieval religious imagery. In other words, he customizes the history of art. He is making it comprehensible to audiences who know who the Flintstones or the Jetsons were but haven't a clue as to medieval masters and their vision. At his best, he also rescues surrealism from the pretensions of Dalí and Breton.

He creolizes, what is more, the perspective of art history with a view from a microscope—*Vivo la Vivo*, where amoeba-like forms swim in an atmosphere of gold—or from a telescope,

trained on a cosmos of clowns—*When the Worlds Collide.*

In the process, Scharf acquires a taste for anachronistic humor. He absorbed images of paleolithic men and women acting out mid-20th century idioms and prejudices, speaking on ram horn telephones and listening to lp's played with the beak of a bird. Such were the ongoing jokes of *The Flintstones* series, perfect for his sensibility. And he memorized the fun and foibles for another cartoon family, the Jetsons, who lived in the future but thought and talked in terms of ca. 1962.

Scharf played back this epoch-colliding nonsense in his own creative terms. You can see this as early as 1980. Witness faux-scrolls, roughly inspired by those found near the Dead Sea. Scharf becomes a mod Isaiah, predicting the future in a made-up calligraphic writing system, vaguely Chinese but with glints of New York graffiti. Scharf set fire to the edges of one scroll to make it seem more ancient. The writings are illumi-nated with marvelous sketches of towers of the future, clearly derived from Orbit City, town of the Jetsons, in turn inspired by what was planned for the New York World's Fair of 1964.

Scharf's shaping of the motif of the flying saucer, also appearing on these scrolls, may well have inspired the emer-gence of that same motif in the art of Keith Haring about the same time, in 1980, however much the control freaks of the estate of Keith Haring contest this. The fluent columns of aesthetic notations, at once framing and commenting on the "sky-pads" and space ships, consciously recall the writing of poems on landscapes from China. These works are remark-able. They indicate that Scharf from the outset was mixing styles, and mixing epochs with a fluency that was to serve him well across the decades.

Still, something else animates his hand, something that traces

also back to his childhood. Scharf's first ambition was to be a meteorologist. When I questioned him about this, his answer was amiable: "I am cold fronts, I am heat waves coming in." This is true. Weather becomes a leitmotif. Mix it right in with the other frequencies-of-phrasing. *The Fun's Inside*, one of his masterpieces dating from 1983, centers the head of a clown over a sea of strokes perhaps inspired by the looping lariats of Jackson Pollock's line. Clown head becomes the blossom of a plant, weaving Scharf's ecstatic ecology back into the composition. Most remarkably, a whole other world appears within the clown's open mouth-emerald hills with emerald Orbit City towers. A front has moved in, coloring the atmosphere scarlet. Clouds billow up and turn into spirals.

In Oceano Vista (1983), the clash of climates comes rolling in—an ultimate cold front, thin-aired and stygian, presses down from outer space; a heat wave colors air red and causes the sea to turn brilliant green. Clown faces echo the contrasts: some are smiling, but one is not. The masterpiece of Scharf's weather paintings is *Cumulonimbliss* (1996). It is delightful to see, for once, one of the base concepts of his oeuvre, the healing efficacy of the laughter brought by clowns, released from clutter and turned into a single declaration. Clowns become thunderheads. Pratfall and horseplay come to the Wasteland. But the clowns are as soft as lambs, as white as fleece. Nevertheless, they dominate the sky. Their horns are lightning. Their limbs are rain.

Scharf is modest about this elegiac triumph. But he does admit that living in Miami had something to do with it: "in Miami the land is flat; there is no landscape. But we have the most amazing cloud shows." Turning clouds into jesters, the painter concludes, "visually lifts you, takes you away from levels mundane." And that is the wisdom of *A Thousand Clowns*: "if things aren't funny then they are just exactly what they are."

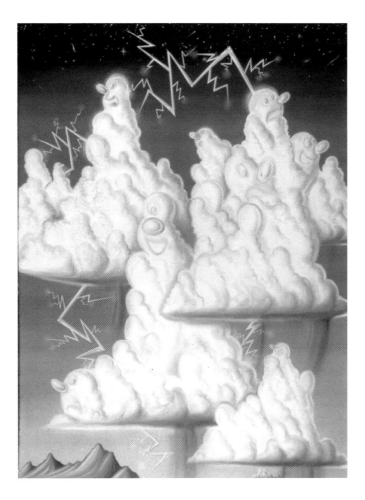

CUMULONIMBLISS, 1996
OIL AND ACRYLIC ON CANVAS
104 x 79 INCHES

EL GNUJ, 1992
OIL, ACRYLIC AND SILKSCREEN INK IN CANVAS
59 x 61 INCHES

Rhizomatic/Schar(morphous): Scharf's Outer/Inner Space Fun

Gregory Bowen

When I was a child, I spoke as a child, I understood as a child, I thought as a child: but when I became a man, I put away childish things.

— 1 Corinthians 13: 11

Kenny Scharf's world is smooth. Not the cool, hip or sly sort of smooth, although that could certainly apply, but, rather, smooth in a theoretical sense. Immersed in Scharf's phosphorescent colors and peeking through the gaping grins of his morphed cartoon characters are foundations of intriguing critical thought concerning our fractured contemporary experience. Faced with the spector of AIDS, jungle deforestation, rampant consumerism and myriad other adult issues, Scharf creates effervescent representations addressing "grown-up" problems filtered through the bluish glow of Saturday morning cartoons. Unlike most of us, when Scharf grew up, he failed to "put away childish things," because for him, it boils down to fun—spiritual, mind-altering, childlike fun. He has always said his work is all about fun, but fun has also brought him trouble. Lamentably, fun is only fun when we are young. Coming of age recontextualizes fun—it becomes leisure, but what is leisure in an age when work is life, and our sense of self is defined by our work?[1] In contemporary American society, there seems to be little room for fun, and thus little room for art about fun. Nonetheless, Scharf has always been serious about fun, and it is within this paradox that things get provocative. Scharf realizes fun has to be taken seriously because it is one of the few things we have left to keep us

smooth in our increasingly striated world.

Labor performs a generalized operation of striation of space-time, a subjection of free action, a nullification of smooth spaces, the origin and means of which is in the essential enterprise of the State. . . .[2]

First coined by composer Pierre Boulez, the concept of smooth and striated space was thoroughly developed by Gilles Deleuze and Félix Guattari in *A Thousand Plateaus: Capitalism and Schizophrenia*.[3] They theorize that time/space—and by extension, experience—exists as smooth, striated, or more commonly, as a mixture of both.[4] Striated space, the domain of the State (the university, the military, the corporation), is hierarchical and is ruled by order, purpose, routine, and control–all attributes that cannot exist in smooth space, which flourishes on possibility and choice. Striated space becomes smooth when confronted by the infinitely small or large. Imagine space as a three- dimensional continuum. Going inward, striation is defeated by declination, an "infinitely small deviation." Expanding outward, striation becomes smooth when confronted by the spiral or vortex, "a figure in which all the points of space are simultaneously occupied according to the laws of frequency"[5] Thus striated space is the space of limits (it is defined in relation to and limited by the smooth), and smooth space is the space of infinite possibilities. Stuart Moulthrop, applying smooth and striated space to the cultural and social domain, notes that "smooth social space is mediated by discontinuities. It propagates in a matrix of breaks, jumps, and implied or contingent connections which are enacted . . . by the viewer or receiver."[6] Plumbing the surface of a Scharf painting is analogous to jumping into this "matrix of contingent connections." The clamor and chaos of his surfaces acti-

vate the viewer's gaze, allowing her to embark on a smooth voyage through Scharf's Anti-Gravity Land.

CARTOON LOGIC

Scharf's fascination with fun, and his first engagement in the smooth, can be traced back to his preoccupation with television and, specifically, with Saturday morning cartoons. Growing up with the television on, Scharf understands cartoon logic. In the world of animation, the impossible is possible; characters do not die when smashed under the weight of an anvil; the laws of physics are easily bent and, more often, broken. No one blinks an eye when, on the television screen, Jane and Elroy Jetson suddenly appear in the prehistoric world of the Flintstones. In fact, the illogical nature of the scene makes it all the more amusing. The absurd freedom of the cartoon became firmly entrenched in Scharf's psyche and would later flood the canvas with disjunctive Technicolor debauchery.

The Jetsons were the first characters to appear in Scharf's paintings, and given his fascination with outer space–the archetypical smooth space—this is no coincidence.[7] Norman M. Klein puts the Jetsons in perspective:

> In the early sixties . . . plastic modernism, beyond Tupperware, suggested the space age, that last frontier promised by President Kennedy, where ever-lighter plastics and vacuum-packed food were needed to send men in aluminum and plastic suits to the moon. The Jetsons are indeed cartoons about "the (p)last(ic) frontier," where suburban bubble

homes look out beyond the space station.[8]

When the eighties arrived and the queue for the shuttle to space never formed, Scharf went to space, smooth space, the only way he knew how—he painted his way there. These early paintings featured scenes brazenly lifted from a Jetsons coloring book, but soon he introduced the prehistoric Flintstones to the mix to create scenes that were unmistakably Scharf. In *Dino Vesuvio* (1982), Fred Flintstone, sporting an Elroy Jetson tattoo on his bared biceps, stands gawking with fear in the foreground as his boulder bungalow, complete with antenna and telephone, is about to be covered with molten lava from an exploding volcano. Scharf places a spiritual reference within the scene, as heavenly bodies (a Judy Jetson winged serpent and heavenly Jetsonian architecture) preside over the spectacle. Mixing histories (the ancient past and distant future) as well as mythologies (the religion of Saturday morning cartoons and Christianity), Scharf points out that within the smooth, fluid space of the cartoon, anything is possible, a fact that he would exploit as he began to morph the various Hanna-Barbera characters into his own outlandish creatures. Televised animation opened the door to a fantasy land that Scharf would term "pop surrealism." Equal parts pop culture icons and symbolic dream imagery, pop surrealism enabled him to create worlds of pure possibility.

WORLDS WITHIN WORLDS

Keith Haring: A lot of times your paintings have a view to another world beyond the one we're in. Like someone's mouth opens up and it's another space beyond that. Either expanding and going into space or getting smaller and going into microspace.

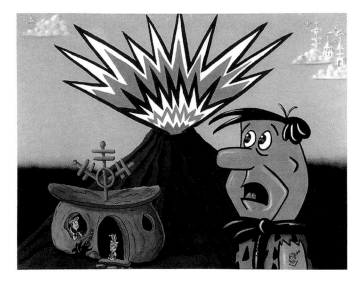

DINO VESUVIO, 1982
ACRYLIC ON CANVAS
36 X 48 INCHES

Kenny Scharf: Well, I guess that has a lot to do with infinity. Going in outer space an infinite amount, as well as inner space where an infinite amount is also the same thing.[9]

Voyaging smoothly is a becoming, and a difficult, uncertain becoming at that.[10]

Scharf's exploration of the microscopic and the macroscopic through the depictions of the atomic and the celestial situates him firmly within Deleuze and Guattari's conception of smooth space, and is most likely a direct outcome of his childhood experience with television. Scharf is often quoted as saying that one of his earliest memories is sitting so close to his family's first color television set that he began to hallucinate while staring at the colored dots on the screen. This is the power of television. It presents viewers infinite worlds beyond their mundane existence. Visions of distant lands flicker with undefined and fuzzy edges, details lost, but the big picture remains. Television in the sixties began to coalesce into a dominant presence in the American scene. It was an occupier and a pacifier that presented information and entertainment in staged, taped and edited packages fit for quick time consumption. Kenny Scharf was one of those kids that sat in front of the television for hours on end watching the world within our world. The television could cause him to hallucinate or take him to sites he had never been—either way, he was off in another space. It was this power, the power of virtual travel, that left an imprint on Scharf.

Moonray Man, Baliroma, The Fun's Inside and *Greenarama* are but a few of the many paintings which propel the viewer into virtual (outer/inner) space. *When the Worlds Collide*, the

quintessential painting of this genre, contains several worlds fighting for our attentive gaze. Creatures big and small careen amidst a seventeen foot field of swirling spirals, cotton candy clouds, celestial bodies, black holes, and primary colored gum balls. Staring out at us with smiles, grimaces and half-hearted glares, Scharf's characters' cavernous mouths disclose vistas into worlds often much more tranquil than the ones they inhabit.

As Scharf has said, "the spiral is easily understood as a means to other levels (worlds)."[11] Gazing into the open mouth of a mirthful character or through the black, swirling hole into another galaxy transports the viewer. While looking at the spiraling forms of electric color on the painting's surface, the

viewer of a Scharf painting can "jack in" through the visual "sockets" within the painting.[12] Scharfian travel–the experience of trekking within his paintings while going nowhere–mirrors television experience and pre-dated the wandering of the cyber-explorer. As is now known, interfacing with world-wide networks destroys one's sense of place and can lead to the sensation of getting lost in space. While the viewer may not get lost in space when gazing at *When the Worlds Collide*, she can indeed take a trip. Deleuze and Guattari explain that to think is to voyage, and it is the most intense voyage of all, for it allows us to escape striated space.[13] Scharf's paintings are unique in this respect because they are not, like many paintings, ends unto themselves. Their meta-level worlds within worlds leave the window of possibility open. They provide multiple points of entry into a space that is not merely illusion-istically vast, but conceptually vast as well.

JUNGLE VISION/HAPTIC SPACE

A rhizome as subterranean stem is absolutely different from roots and radicles. Bulbs and tubers are rhizomes. Plants with roots or radicles may be rhizomorphic in other respects altogether: the question is whether plant life in its specificity is not entirely rhizomatic. Even some animals are, in their pack form. Rats are rhizomes. Burrows are too, in all of their functions of shelter, supply, movement, evasion, and breakout. The rhizome itself assumes very diverse forms, from ramified surface extension in all directions to concretion into bulbs and tubers. When rats swarm over each other.[14]

Beginning in 1982 with *The Jungle*, and continuing in some form or another into the present work, Scharf's obsession with the tropical rainforest and the fantastic growth associated with it

appears repeatedly. The dense vegetation has been an inspiration and aspiration. The "yard" at his Miami home has overgrown into a lush oasis surrounded by a suburban community which favors manicured, astro-turf-like lawns. The small plot of earth behind his warehouse studio has also become a virtual jungle, grown from the discarded seeds and pits of the fruit Scharf eats while he works. Scharf has a special touch, a green thumb if you will, that is nurtured by the warmth of his homes in Miami and Brazil. Thus, it is no surprise that the jungle, with its mesh of intertwining vines, would work its way into his paintings. Scharf goes inside and explores the space of the jungle, albeit through the cartoon lens of a Saturday morning explorer. His vines become snake-like bodies that end and begin with grinning faces. Titles such as *Juicy Jungle, Junglina, Jungle Jism, Jungle Juice,* and *Junguloony* conjure images ripe with fertility, festivity and fun.

Scharf's jungles are mass entanglements of vines that are sim-

GLOBUP, 1989
OIL ON CANVAS WITH ALUMINUM FRAME
120 x 96 INCHES

ilar in concept to Deleuze and Guattari's notion of the rhizome. His vision of the jungle, which takes us into its inner recesses, separates him from the tradition, practiced by Frederick E. Church, Thomas Cole and the rest of the Hudson River School, of depicting the landscape as vast panorama. Their method of capturing the world, using the distant vision of optical space, sets them within the striated. Scharf, in contrast, provides the viewer a rhizomic space—in Deleuze and Guattari's terms, a "close vision-haptic space." According to these philosophers, "the Smooth is both the object of a close vision par excellence and the element of a haptic space (which may be as much visual or auditory as tactile). The Striated, on the contrary, relates to a more distant vision, and a more optical space. . ."[15] Haptic space dictates that the eye has the ability to impart sound, taste, scent and touch to the brain as well as sight. Scharf's jungleworks demand this intense, active viewing which involves all the senses. They are large-scale (the smallest being five by six feet), hyperreal depictions of jungle details whose inner workings hold us close to the surface. In *Junglina*, for example, psychedelically colored rivulets are the backdrop for a lush tropical playground inhabited by googily-three-eyed mutants, bulbous cyclopes, and beautiful butterflies. As the series progresses, the jungle paintings become more abstract (unreal, plastic), and his line is cut loose from the demands of form. In *Growthalogical Organizzquizit*, there are only remnants of recognizable objects. His trademark faces appear as plastic blobs, sans eyeballs and cartoon teeth, which melt into rhizomorphous forms that intermingle, creating a cacophonous network writhing with nervous energy. While viewing this twelve foot long painting, our eyes travel from one globule to the next, and we become pleasurably enmeshed as we strug-

gle to find our way through the interlinking vines of Scharf's jungle/haptic space.

Globup, while not a jungle painting in the traditional sense, extends the notion of jungle space to the limits and provides a perfect haptic space. One of a series of almost purely abstract paintings, this work envelopes the viewer in candy-colored globules that are enticing to the tongue as well as the eyes. The glistening forms beg to be touched and are colored in terms that can only be described as shrill. We can imagine the squeak from our fingers rubbing against the vinyl-like forms reminiscent of the flotation devices our parents made us wear in the pool when we were young. Lacking the over-grown vines of the jungle paintings, *Globup* nonetheless entwines us, pulling us into its immersive environment through practically all five senses.

FULL CIRCLE(?)

A rhizome has no beginning or end; it is always in the middle, between things, interbeing, intermezzo. [16]

Scharf's 1995 New York exhibition was aptly titled Full Circle.[17] Layered over geometric primary colored washes were his plasticized trademarks: serpentine, spermatozoic creatures, jungle vines, architectural forms and mad/glad guys. Paintings such as *Modernorganica* are reminiscent of the in-your-face canvases of the eighties, but their space is markedly different from early work in which outer space, surrealistic settings were the norm. The worlds within worlds of the early paint-ings created a space that was chaotic and layered, but with depth. The white grounds and geometric patterning of the full

circle paintings form a non-space, a space between deep and shallow, analogous to the layered space of the computer screen. It is within the realm of the screen that Scharf's art went full circle in a more fundamental manner.

In 1995 Scharf, once again, "jacked in." Foregoing the conventional home page—a couple of scanned images and a hotlink list—Scharf jumped into cyberspace headfirst with the Total Cosmic Cavern. Scharf first customized a New York nightclub dubbed the Tunnel. In typical Scharfian fashion (in all senses of the word), the Tunnel was transformed into a psychotropic fantasy land dominated by pink fur walls, floor-to-ceiling lava lamps, day-glo paint, and biomorphic furniture. Visitors to the club get the unique experience of being in one of Scharf's "Closet" installations, but those that can't make it to New York, can get there virtually because his on-line version of the club mirrors the real thing.

The Total Cosmic Cavern—part chat room, part nightclub and part art museum—is an eclectic mix which lets the viewer behold the world of Scharf's paintings and installations in a way that was never before possible. The space that was once (in the early 80s) only hinted at conceptually in paintings such as *Op Bop*, is now virtually possible. We can now explore the paintings by moving around in them. The gaping crack in the landscape of *Sajippe Kraka Joujes* is now a link that leads to another world (painting). Likewise, the underwater cave—the lair for a pair of little beady eyes seen in *In Ecstasy*—serves as a passageway that leads to the third stall of the "femalian's" room back in the club. These interactive links create space, cyberspace, haptic space, smooth space, as the viewer's avatar slips through the cracks in the screen. His digitally

MODERNORGANICA, 1995
OIL AND ACRYLIC ON CANVAS
80 x 104 INCHES

captured paintings now create a three-dimensional techno-fun house. Within the virtually infinite space of the screen the viewers wander endlessly and interact with others as if they were part of a bacchanalian "rave."[18] Cyber/ Technoculture has given Scharf the power to transform ideas into experience and the ability to get a little closer to the infinite possibility that is outer space. He has taken this power and gone full circle, a circle that begins and ends within the smooth space of fun.[19]

On the ceiling I painted a fluorescent blue and orange spiral. I used to take mushrooms, lie on my back and stare at the spiral until it slowly dropped from the ceiling. I'd leave my body, go inside the spiral and float around in endless space. [20]

The desire to transcend our mundane experience, to perhaps "float around in endless space," starts when we are young. As a child I remember my friends and I spinning in circles until we would fall to the ground overcome with dizziness. Lying with our backs to the earth, the sensation of movement persisted. We were flying through the swirling, spiraling clouds even though we were planted firmly on the ground. Silly, innocent fun, this sense of pure abandonment, of getting lost within one's self, quickly vanishes as we grow up and leave "childish things" behind. Kenny Scharf reminds us that "the fun's inside." It is inside the spiraling vortex, the conduit to worlds beyond our quotidian existence; it exists in the smallest deviation between atoms, inside the code that constructs all that we know; and it is inside us, back in the recesses of our psyches where little kids live. Fun is smooth because fun exists as contingency and possibility, a diversion from work. Fun is freedom to do anything but what is needed for survival, and

this freedom can only exist in a space free from the demands of striation. Scharf's world, with its animated denizens engulfed in pleasure for pleasure's sake, its psychedelically colored jungles, and its cybernetic merriment encapsulates these metaphors, offering us portals out of the striated and into a world of smooth sailing.

. . . the future is bizarre, infinite and limitless.[21]

1. If contemporary advertising is indeed a reflection of American culture, then this would seem to be a truism. BMW, Double Mint Gum and many others have both print and television advertisements lamenting the loss of fun due to the demands of work.

2. Gilles Deleuze and Félix Guattari, *A Thousand Plateaus: Capitalism and Schizophrenia* (Minneapolis: University of Minnesota Press, 1987), 490.

3. Ibid., 361-362. Boulez wrote of smooth and striated space referring to music. In striated space the measure is always assignable. In smooth space the measure can be "effected at will". The two are the difference between playing written music and pure improvisation.

4. There is not a didactic relationship between the two spaces. It is important to note that our experience of smooth and striated space most often exists in mixture. Pure smooth and striated space exists mainly in theory.

5. Ibid., 489.

6. Stuart Moulthrop, "Rhizome and Resistance: Hypertext and the Dreams of a New Culture." in *Hyper/Text/Theory*, ed. George P. Landow (Baltimore: Johns Hopkins University Press, 1994), 303.

7. Scharf came of age during the space-race between the United States and Russia, and the optimism of the late 50s and early 60s became thoroughly entrenched in his psyche. When Scharf moved from California

to New York in 1979, he took on the leather-clad, sci-fi persona of Jet Scharf, and began to paint outer space scenes including *Self-portrait with Cadillac*. Set in the moon-like desert, the painting features a Cadillac flying through star-filled night sky.

8. Norman M. Klein, *Seven Seconds: The Life and Death of the American Animated Cartoon* (London: Verso, 1993), 245.

9. Keith Haring, "Kenny Scharf: A Talk with Keith Haring." *Flash Art International* 120 (January 1985): 17.

10. Deleuze and Guattari, 482.

11. Kenny Scharf, "Jetsonism is Nirvana." in *Kenny Scharf: 1983*, (New York: Tony Shafrazi Gallery, 1983), 6.

12. There are many popular culture references to jacking in. It basically refers to human interface with some sort of technology as in William Gibson's *Neuromancer* where humans interface with immense computer networks, or as in the movie *Strange Days* in which the new drug is "playback"—a virtual reality experience that the user experiences though a neural net placed on the head. In both instances, the mind "travels" while the body remains fixed.

13. Deleuze and Guattari, 482..

14. Ibid., 6.

15. Ibid., 493.

16. Ibid., 25. The rhizome lacks destination. It is the "inbetween". Deleuze and Guattari note that the questions Where are you going?; Where are you coming from?; and What are you heading for? are totally useless. There are no starts and finishes, just comings and goings.

17. The exhibition took place at the Tony Shafrazi Gallery.

18. Michael Menser, "Becoming-Heterarch: On Technocultural Theory, Minor Science, and the Production of Space," in *Technoscience and Cyberculture*, ed. Stanley Aronowitz et. al. (New York: Routledge, 1996), 304. Raves and rave-culture in general exists in smooth space. They thrive on unpredictability and produce nomadic space, or what Michael Menser terms, a "Temporary Autonomous Zone." He states that "ravers . . .demonstrate possible social organizations that are too

irruptive and nomadic to ever 'settle' into a stratified social formation."

19. An Intel commercial, set within a disco-lab complete with flashing lights and a "Play that Funky Music" soundtrack, contrasts its new and improved processor, with MMX technology, with its old chip which is made in a staid, stark lab. The message is that improved technology not only generates fun but is necessary for fun.

20. Steven Hager, "Mutants from Outer Space: Kenny Scharf's New Psychedelia." *High Times* (February 1985):48. Scharf is talking here of his first black light, Day-Glo, found-object closet installation.

21. Kenny Scharf, 7.

HISTORY OF THE WORLD, 1987
OIL AND SPRAYPAINT ON CANVAS
91 x 115 1/2 INCHES

WHO WANTS GUM?
APOCALYPTIC FUN IN
KENNY'S JELLY JUNGLE
BILL MCBRIDE

In Kenny Scharf's 1984 painting *Bubblegum Gush*, an almost palpably soft and luscious, pink, gummy goo dominates the top border of the canvas and is squeezed over to the right side of the painting much the way our tongues and teeth push out actual bubblegum in preparation to blow a bubble. In the painting, the teeth and tongue are replaced by a cherry-red, six-sided star creature encased in a blue and yellow vacuole which forces the pink stuff to ooze half way down the painting and result finally in a bubble, which in fact, we discover, is a bubble-head. More precisely it is one of Scharf's signature biomorphic bubble-gumby guys with big bulbous nose, single droopy eye and extra-wide grin. While this pink bubblegum substance and its resultant bubble-head creature are only part of an even more pleasurable and apocalyptically dense painting, it is the dominant insistence of this Bubblegum effect here and in so many other of Kenny Scharf's pieces which packs such an immediate painterly punch. Up until now "Bubblegum" as an aesthetic judgment has been wielded exclusively as a high-art put-down of the popular. Kenny Scharf is all about the popular. He purposefully dons the pop mantle himself by labeling his work "*pop*-surrealism." As to the cultural etymology of the term "Bubblegum," it gains parlance in the late '60s music industry when Leonard Cohen, heavy rockers like Eric Clapton, and critics searched for a way to express their self-important outrage at the wild popularity of the adolescent jingle-jangle of this candied pop rock.[1] Knowing full well this negative judgment, I insist on the term "Bubblegum" anyway in hopes of forcing the issue about the uncritically snobbish response that Bubblegum work like Scharf's "pop"

fun and freedom bring out in some of us some of the time. This typical anti-Bubblegum reaction is like our automatic groans when we hear a pun. And while Bubblegum brings out the fuddy-duddy in a few, it brings out the youngster in most. I plan to demonstrate how these exceptional paintings/customized objects/black light closets call for a sweetly playful stretching, shaping and popping of such a sourpuss aesthetic judgment as they both evoke and take us out of our apocalyptic bummers.

I

I don't believe you'd like it, you wouldn't like it here.
There ain't no entertainment, and the judgments are severe.
The maestro says it's Mozart but it sounds like Bubblegum to me
When you're waiting for the miracle, for the miracle to come.

> "Waiting for the Miracle"(Leonard Cohen-Sharon Robinson),
> as recorded by Leonard Cohen, 1992

The argument against the colorfully dyed, chewy sweet treat and its aesthetic namesake is at once sober-minded and frankly parental: bubblegum loses its flavor overnight, it is ephemeral, doesn't last. It is a non-nutritional, nonsensical junk-food whose passing burst of flavor and sugar rot your teeth just as Bubblegum art and music rot your mind. One of the historically admirable traits of Bubblegum music, which Mr. Scharf's "cartoonish," Bubblegum paintings and their in-your-face frivolous titles share, however, is the ability to turn defeat into conquest in classic jujitsu style. So when I dub paintings such as *Bubblegum Gush* or *Red Jello Fello* as "Bubblegum," I intend it as a purposefully strategic, positive shifting of the term in order to praise this supposedly "immature," frivolous, hedonistic work *without* apology or guilt, and thereby embrace with pride a former put-down. In this manner I model my rhetorical strategy after, for example, the organizers of

BUBBLEGUM GUSH, 1984
OIL, ACRYLIC, ENAMEL AND SPRAYPAINT ON CANVAS
120 x 96 INCHES

"Queer Nation," who wish to overturn a hasty and uncritical prejudgment by embracing the malediction.

II

If you're looking for a sunshine boy
Come with me I can give you some
We'll climb a rainbow ladder to the sky
Just you and I, we will fly
To the yellow ball of butter
Where the clouds are as fluffy as a parachute sail
In the Jelly Jungle
of Orange Marmalade-lade-lade-lade-lade-lade-lade-lade-lade-lade
There are tangerine dreams waiting for you
in Orange Marmalade-lade-lade-lade-lade-lade-lade-lade-lade-lade
. Carrot trumpets play
Violins grow like peaches in the sun all day
In the Jelly Jungle
of Orange Marmalade-lade-lade-lade-lade-lade-lade-lade-lade-lade
There are tangerine dreams waiting for you
in Orange Marmalade-lade-lade-lade-lade-lade-lade-lade-lade-lade

> "Jelly Jungle" (P. Leka-S. Pinx), as recorded by the
> Lemon Pipers, 1969

I use the term Bubblegum in order to find a way to discuss the so-called purely abstract, globby form painting, most fully realized in the paintings *Obglob*, *Globup* and *Curvabolatrap*; but Bubblegum is present as background (or is it foreground?) to the silkscreen consumerist pieces, and if you look closely enough, Bubblegum is present even in *Globup's* stylistically polar opposite, that is to say, in the natural history schoolbook wildlife paintings such as *Monkidew*. Nearly hidden in this otherwise realist/naturalist depiction of jungle flora and fauna, slinking around on a tree limb at the extreme left side of the painting, is a licorice black, bubblegumby snake replete with bulbous nose and cutesy open mouth.

Scharf's Bubblegum is a pleasure in form, an inviting, practically edible sweetness and shine, super-saturated colors gathered up in a rhythm of anarchical shapes in either spraypaint or the more luscious oil, which bubble up and down like the molten plastic of the equally maligned Lava Lamp, whose manifesto, coincidentally, talks Scharftalk:

> Lava is a philosophy. The primordial ooze that once ruled our world has been captured in perpetual motion. Lava is the moment. Its ever changing patterns are hypnotizing yet invigorating. Lava is an art form. A classic and at the same time. . . progressive. Lava is prehistoric and postmodern. Lava is here to stay.

Of course the effects of the Lava Lamp unfold in time in a way paintings do not, but hypnotizing and invigorating Bubblegum—whether the headshop toy or Scharf's paintings—is certainly all about desire and our reaction to it.

III

So many fantastic colors are fillin' a wonderland.
Many fantastic colors makes me feel so good.

"Swlabr" (Bruce/Brown), as recorded by Cream, 1967.

Bubblegum is all about fun—it serves no other real purpose. One chews not in order to break the gum down into swallowable bits, but simply for the pleasure of chewing: and now we've located the (harmless) threat in Mr. Scharf's paintings. It is this non-utilitarian, for nothing but its own sake quality that prompts the humorless, adult-minded dismissal of Scharf's works as "cartoonish" and frivolous. Part of what is behind the two-faced struggle of this high-art dismissal concerns adults scolding *themselves* to grow up. Since the oppo-

TANTRIC JUDY, 1981
OIL, ACRYLIC, ENAMEL AND SPRAYPAINT ON CANVAS
42 x 48 INCHES

76

site of work is fun, and Scharf is all about fun, it stands to reason that this cannot be serious work. But Scharf is serious about fun. Kenny Scharf's paintings willfully foreground this Bubblegum look as an art-for-art's-sake metaphor for fun and, as will become clear, he inscribes this fun with an ethical and apocalyptic mark.

Globup is a riotous schema of richly colored, softly segmented, treaded/contoured, pneumatic candy globs (a la Claes Oldenburg)[2] which populate to near bursting the entire canvas as they push up and squeeze against each other. It is a dance mix of multi-colored sugar pillows in dark chocolaty, effervescent root beer, and butterscotch browns, lemon yellow, lime green, mandarin orange, creamy white vanilla, licorice black, pepperminty blue, wintergreen green, artificial grape purple, and of course, bubblegum pink. There is no true beginning point here, the painting can be read in any number of directions; one picks up the rhythm of this candied color-chart and joyfully follows the dynamism of the pushing, pulling, squeezing, and globbing up.

IV

scharf, GERMAN *adj.* sharp, cutting; pointed; acute; keen; rigorous; *scharf bewachen* to watch closely; *scharfe Patrone* live cartridge; *scharfe Zucht* rigid discipline; *scharf reiten* to ride hard; *scharf sichtig* sharp sighted; penetrating; *scharf sinnig* sagacious, ingenious; *Scharf, masculine noun: Scharf blick* penetrating glance; keen eye; acuteness; *Scharf macher* agitator, firebrand.

Because *scharf* is coincidentally also German slang for "horny," and nearly all pop music references to sweets are euphemisms for sex, I would like to consider briefly the Bubblegum sex in shiny Scharf packets, that is, the early 80s erotica of *Elroy and Leroy*, *Divine Light in Capri*, and *Tantric Judy*. In the nudie Judy painting we have a voluptuous and athletic teen-aged Ms. Jetson replete with lush curled and erect white pony tail, busty

chest, open and pubic-hairless pudenda, muscular legs balancing on the tip of a small green pyramid with white border in whose center is a white-outlined red dot which doubles the one at the center of her forehead. What is most charming and Bubblegum-like about the picture are the eight menacing snakearms with their cutesy grimaces and unlikely open-mouthed threats to strike. They can't help but come off as darling—something akin to the cartoon utopic of a Jim Henson's Shiva/Medusa Muppet Serpent Babies.

In *Elroy and Leroy*, the naked boys have vacant, soulless tiddlywink-disk-eyes and 50s space suits suggested elegantly by the triangular white collar and electrode beanie. Their arms and legs intersect as they nurse the milk-packed teats of an otherwise emaciated, monstrously huge, electric blue she-wolf. Those who like to smell the postmodern and report the stench, sniff it here, recognizing that like James Joyce's riff on Homer, here's Kenny Scharf's postmodern reworking of the famous Roman statuary which depicts the founding of Rome by Romulus and Remus. But, they might very well go on to argue, Scharf dares to set this new Rome on the surface of a cartoon purple moon in the future and shamelessly cast the classically mythological figures as simple and silly Hanna-Barbera characters. This is Bubblegummification. I nonetheless admire the audacity of *doubling* Elroy, creating the non-existent, identity-challenging Leroy. But what stands out most for me in this concoction is how Scharf has modified erotically Hanna-Barbera's soft and pudgy Elroy into the much svelter, hard body and has given each, adorable and non-threatening, hairless, adolescent erections. This doubling and baring of the eroticized and therefore "detourned" Hanna-Barbera body is continued in *Divine Light in Capri* with its double Wilma Flintstones sporting utopic breasts. Like the straight female, California based "slash zines" whose erotic narratives and explicit illustrations depict hardbodied Kirks

and Spocks engaged in homosexual lovemaking, or all those hardcore porn images available on the internet involving, for example, the Simpson characters so amorously engaged, Scharf's early 80s erotica not only provides a sexual charge, but also the shock of seeing our media friends outside of their "home," and enacting a dimension of their lives always hidden from view. Perhaps there is a hint of infantile sexuality packed with the uncanny power of the primal scene here.

By placing these instantly recognizable characters in brand new and provocative settings—George Jetson sweating out a meteor shower, Judy Jetson as a mermaid, Elroy Jetson as a worm—Kenny Scharf detourns his found objects in the tradition of Duchamp's urinal, titled *Fountain,* and mustachioed Mona Lisa. JLP of *Figaroscope* tentatively agrees that in Scharf's oeuvre, perhaps ". . . il y a detournement." Detournement is a term championed by Guy Debord (of Paris, May 1968 fame) and the Situationists in the early sixties and is founded on the surrealist and modern poetic discoveries that the juxtaposing of nearly any two objects will force a fruitful reexamination of both. To "detourn" in the original French has numerous meanings but the most relevant here are how one can detourn/corrupt a minor, detourn/hijack a plane, and detourn/embezzle funds. While "corrupting," "hijacking," and "embezzling" are condemnable acts in "real" life, they are de rigeur practices of all engaged art. So-called "borrowings" or plagiarism are a constant throughout art history and pre-history. DeBord claims that: "The construction of situations begins on the ruins of the modern spectacle." And the Russian Formalists believed that all art could be reduced to the device known variously as estrangement, defamiliarization, and later, Brecht's alienation effect. Bubblegum is postmodern, then, in that everything is stylized, mannered, in quotes, defamiliarized, detourned. Look at how nature is depicted in the Lemon Pipers' "Jelly Jungle." Its affected/customized voice sings

KENNY SCHARF PHOTOGRAPHED BY CHRISTOPHER MAKOS, 1986

meaningful misprison and drug-inverted malapropism: "violins grow like peaches in the sun all day." It *should* be peaches grow like violins![3]

V

Please don't sad, if it was a straight mind you had,
We wouldn't have known you all these years.

> "Dear Mr. Fantasy" (Winwood, Capaldi, Wood), as recorded by Traffic from *Dear Mr. Fantasy*, 1968

Blanche: Straight? Straight? How can the human mind be straight?

> *Streetcar Named Desire* (Tennessee Williams' screenplay for Elia Kazan's 1951 film).

Double Entendre is a Scharfian study of doubleness in that the canvas and frame are "split" down the middle, with not quite a perfect and therefore distorted mirror image of the left, blue side of the painting doubled on the orange-red, right side. The blue bubblegum is contoured while the orange-red bubblegum merely carries the shine. On closer inspection the two sides are almost more different than alike. Double meaning? In typical postmodern fashion there is nearly an absence of meaning, ironic and poignant in a painting that boasts two. But what this painting does contain at its center is the vanishing point of the "mirror," that is, a pictorial representation of a *mise en abyme* that haunts the center of the painting. Sounding like a spokesperson for Oswald Spengler's Faustian West, that is, speaking for us all, Scharf describes the devilish bargain he has struck by referring to himself as both consumer and consumer hater, both victim and perpetrator of a destructive consumerism. Dan Cameron's essay from the catalogue of the *El Mundo de Kenny Scharf* exhibit he curated reveals most of the Scharfian bipolarities: popular taste vs. expert opinion, parody vs. infatuation, wide eyed glee vs. terror, hilarity vs.

cosmic terror, celebration vs. revelation, toward vs. away, glorification vs. derision, optimism vs. pessimism, indulgence vs. unsettlement and so on, and I would add troubling apocalyptic bummer vs. the Bubblegum freedom to take us out of it. The liberating achievement of post-structuralism's critical doubt has been its philosophical interrogation of such doubles by questioning the binary structure of language and thought, and by its willingness to question western philosophy's shrill insistence on the law of (against) contradiction. These seriously playful rhetorical investigations and manipulations of deconstruction have provided the most used and abused method for such operations.

VI

Sfumato [Italian, literally "smoked."]—Another quality which was adopted from Leonardo . . . was the "sfumato" system—the imperceptible softening of the transitions in half-tints and shadows.

The Material History of Oil Painting, Sir Charles Eastlake, 1847

It is commonplace to remark that this tenacious dyadic logic dominates our western thinking: day/night, male/ female, black/white, etc. An entire computer language, one capable of the replication and therefore sophistication of our own language can simply fly on a series of zeros and ones. In the visual realm this logic is represented by the pairs: form/content, figure/ground, beautiful/sublime, and, most simply, light/dark. As a response to and a way out of this apparent straight-jacket, consider what Hegel, in his *Aesthetics: Lectures on Fine Art,* has to say about the philosophical underpinnings of the painterly technique known as *sfumato*—the "smoky" blurring of gradations between black and white. Hegel speaks of the "magic of its tones of colour and their contrast, and the fusion and play of their harmony" which creates a "fusion of colors" and "wealthy play of transitions and mediations which

MESSAGE FROM THE MOLECULAR MESSIAH, 1983
OIL AND SPRAYPAINT ON CANVAS
84 x 60 INCHES

put everything in a flow and interconnection and proceed to the most delicate nuances." There is in Scharf's work the willingness, propensity and adeptness to combine, miscegenate, and cross borders with his creatures—this is what can happen when worlds, in the right hands, collide. The Scharf Synthesizer says: "I like to mix things up. . . this kind of metamorphosis: Flintjet, Jetstone." An amalgam of a number of characters spawns *El Fredix*, although Scharf names Wilma Flintstone and George Jetson specifically as progenitors in the 1983 addendum to his notebook entries reprinted in the small Tony Shafrazi catalogue. By attributing the births of these peculiar offspring to what he calls "time-splats," which we learn can be any "catastrophic superpowered happening," Kenny Scharf indicates the importance of the apocalyptic mutation in his work. There is radical, challenging potential in the sfumato system to breach philosophy's law of contradiction, and Kenny Scharf's syntheses remind me of human, animal and furniture flesh transmutations by Francis Bacon.[4]

VII

I looked to the sky
Where an elephant's eye
Was looking at me
From a Bubblegum tree.

> "Hole in My Shoe" (Dave Mason), as recorded by Traffic, 1968

There is an inexhaustibility about bubblegum that connects it somehow with: (1) plutonium's million years' half-life, (2) broadcast TV signals endlessly bouncing off the moon and other satellites, and (3) the lysergic "will we ever come down?" effect. In an interesting coincidence all three seemingly immortal substances are "discovered" roughly at the same time, just prior to and during WWII, and set the stage for that inexhaustible, continuously reinvented substance known as

rock and roll (which will never die!) And of course the hybrid, bricolaged rock and roll music heralds what will become for many the inauguration of the postmodern. The Bubblegum I'm trying to embrace and stick onto the work of Kenny Scharf is generational, and has everything to do with the youthful revolt, electric artificiality, and musical melting pot that is Rock & Roll—which is both R & B slang for sexual intercourse and perhaps best described as the music your parents hate.

In *The Aesthetics of Rock,* R. Meltzer describes rock music and attitude as the "ultimate in adolescent drag." So this Bubblegum aesthetic gets from Rock & Roll its willfully arrested development, its Hamlet/Holden Caufield/Peter Pan impersonation, its "just for kids" slacker rejection of adults, or at least what is perceived as the adult sellout to strict models for gender and success (among other sellouts), and its adamic rejection of work. One critic reminds us that "Scharf has maintained his childhood propensity to see faces everywhere—in houses, cars and clouds." The artist's willful "cartoonishness" beckons us back to the wonder of Saturday morning and asks: At what point did cartoons stop talking to us, cease being valid? Have we bargained away the childlike imaginative freedom of the playhouse for the adultlike circumspection of the workhouse? You owe it to yourself to either create with your friends, as Kenny Scharf encourages, your own "black-light closet" or visit one of Kenny Scharf's if you want some kindergarten bliss. There's an almost vigilant childishness about Scharf's work (as he retains his diminutive kid's name—Kenny—into adulthood), a purity of inspiration very much part of his youthful generation. In fact this work speaks to nearly all of our generations as we "build that bridge to the twenty-first century," except for those, that is, who, no matter what their age, desperately clutch onto a dying twentieth century nostalgia for world wars and cold wars and hasty, rigid distinctions about patriots and traitors, high art and low

art, masculinity and femininity, ecstasy and sobriety.

VIII

I like the jungle/I like its style/Keep it growing, keep it wild./Let it grow for miles and miles and miles..../Juicy Jungle's getting smaller year after year/Juicy Jungle's gonna disappear. Leave it alone."

> "Juicy Jungle" (Fred Schneider/John Cote), as recorded by the B-52's, 1986

Regarding his true "maturity," consider the ArT RANDOM *Kenny Scharf: Jungle Book*. In it we find a wealth of his jungle paintings oozing jelly as they too partake in the Bubblegum aesthetic with fantastic colors, jungloony creatures, and impossible artificiality. These paintings sell the best of all of Scharf's work, and they carry the strongest environmental message, that is, the Boschian apocalyptic message. Fulfilling the aesthetic dicta of Horace, Scharf both delights and instructs by contextualizing reproductions of the paintings *Juicy Jungle, Jungle Jism, Junglina, Jungle Juice, Jungloony*, and *Save the Jungle* with photos documenting the devastation of deforestation, and text which gradually unfolds throughout the book: "save the jungle...let it grow...the earths heart, lungs & soul." Contained in the ArT RANDOM *Jungle Book* text is the sci-fi/aboriginal native insight that *humans are not separate from nature*. What are those nuclear-mutated, monstrous movie ants, crabs, and geckos all about if not Bubblegummized warnings about how precious and delicately interconnected all life is? So many of Scharf's creatures originate from and remain part of their landscape, as in *Scape* and *Bubblegum Gush*. This ecological insight about the connectedness of the creatures and the planet is the main "message" of the exemplary sci-fi classic *The Angry Red Planet*—"angry" because the rational, scientific humans don't get it. When Kenny Scharf became much more

JUNGLE JISM 1985
ACRYLIC ON CANVAS
112 x 81 INCHES

explicit about his environmentalism with eco-disaster head-
lines, silkscreen images of consumerism, and the rest, the
critics began to get it, but get it wrong, too, when they
claimed he had finally grown up, like Marc H. Miller refer-
ring specifically to "Scharf's mature work." The earlier work
must have looked like silly Bubblegum to him. But Leonard
Cohen's Maestro is just trying to hide the fact that in the end
Mozart sounds like Bubblegum, too, particularly when, like
Mr. Cohen's persona in the song, you're waiting for the end
of the world and a miracle—God or Godot or the bomb or
AIDS or love to come. This revelatory apocalyptic sensibility
is the serious aspect that complements the otherwise carefree
quality of the Bubblegum aesthetic.

IX

Oh say can you see
It's really such a mess
Every inch of earth is a fighting nest
Giant pencil and lipstick tube-shaped things
Continue to rain and cause screaming pain
And the Artic stains from silver blue to bloody red
As our feet find the sands and the sea—it's straight ahead.

> "1983(A Merman I Should Turn to Be)" (Jimi Hendrix),
> from *Electric Ladyland*, 1968

When you gaze at a Scharf painting it is immediately clear
that the painter has gazed into the abyss, and, as Nietzsche
warned/invited, it has gazed into him. It is also evident that
the painter has marked the painting with this apocalyptic
moment in order for it to gaze back at you. This mannerist
mark and its re-marking is what constitutes, along with, of
course, the yummy candy-colored clowns and shapes, and
whimsical picture titles, the *drama* of Kenny Scharf's pop-
surrealism. Experiencing and participating in that drama is
what one might call getting "scharfed." Whether it is the

Boschian/Wizard of Oz jungle paintings (where it should be clear that the trees are humans too!) or the more blatantly environmental/consumerist silkscreened pieces, he shows you in traditional sci-fi fashion that he has pondered the ecological abyss toward which we are all headed. And when you encounter those goofy-ecstatic yet wise, spaced-out, funny-faces you see resplendent the uncanny existential and spiritual experience which results from an encounter with one's own inevitable death. This all-too-human confrontation with mortality can be reached by prayerful meditation, nature contemplation, and certain ecstatic drug experiences. Remember his youthful manifesto: "mushrooms + tv childhood = pop surrealism". I can't think of another contemporary painter who so insistently and specifically asks Jimi Hendrix's seriously playful, question: "Are You Experienced? Not necessarily stoned, but beautiful." Here is what Ann Magnuson calls "art for the end of the millennium," or, as she puts another way, Kenny Scharf's "Fin-ism."

You can find this anxious wisdom in the decapitated Bellini head helplessly witnessing the destructive might of the green and pink volcano in *In Ecstasy*, and in *Message from the Molecular Messiah* with the lime green Bubblegumby figure's open-mouthed, eye-bulging recoil at the coming of the new Jesus. Or the teeth-gritting, strung-out, red bubble-guy adrift in an impossible lemon yellow Mad Max apocalyptic desert sky in *Creamdream*. And in the equally Bubblegummy, more recent *Scape*, there is a Bubblegum messiah up in the sky who matches "in his own image" the same pink color of the creatures which Scharf demonstrates are spiritually and ecologically one. This uncanny Scharfian drama is there, too, in the doubtful union of *Aqua Pollination,* with its abysmal distance between the waterfall-separated, detourned Hanna-Barbera male and female creatures, and it is there in the knowing stoned eyes and e-z wide grins of *Sajippe Kraka Joujes*. One can locate a more bummer-inflected countenance in any of

SPINSHINE, 1985-6
OIL, ACRYLIC, ENAMEL AND SPRAYPAINT ON CANVAS
48 INCHES DIAMETER

R. Crumb's wretches, and Peter Max usually depicts this spaced-out contemplation as star-spangled and peaceful, but always lacking Scharf's sense of humor.[5] Bubblegum cannot work without an irrepressible sense of humor, a facility for fun.

The abyss is, in fact, pictorially rendered as the center of the vortex or mandala in paintings like *Destination Fun, Hypnozen, Spinshine* and his most recent *Mamdalila*. At the center of the mandala we find the powerful vortex, and in the films of Hitchcock we find bummer versions of that vortex, such as *Psycho*'s camera spiraling down to the shower drain and *Vertigo*'s simultaneous tracking and zooming shot, intended to cinematically represent the dizzying effect of this apocalyptic contemplation of both womb and tomb. Meditating on either the center of the vortex of these Scharf paintings or the Day-Glo spiral on the ceiling of a Scharf black-light closet brings you to the infinite regress of mise-en-abyme. Speaking the language of aesthetics, these are marks of the sublime. Kenny Scharf's pop spiritualism is founded on the spiral. In an early notebook, Scharf writes: "The spiral is easily understood as a means to other levels (worlds). For example the tornado, the bathtub drain spiral where entering can take place (air through water). Galaxies are spirals. Suction-black holes? Spirals are universal in space, in nature and in culture." Dan Cameron is on to this apocalyptic/sublime element and finds a precedent in Dali's "high-anxiety ambience" and goes on to place the Scharfian sublime in the "typically American" context of the "individual psyche engaged in metaphysical exchange with the cosmos."

In his third and final critique, *The Critique of Aesthetic Judgment*, Kant rehearses the pathetic/heroic drama of man's encounter with the immensity of nature. In the first stage, human perception is incapable of taking in that immensity at a range close enough for an authentic judgment. We experience a

moment of impotence which is immediately followed by a second stage, a compensatory recoil and recourse to our eidetic faculty of Imagination. We are redeemed and gladdened by the power of our imagination to *represent* the immensity, and thereby, with a picture, we are now capable of rendering the sublime. It is this gladdening technique that Cameron rightfully attributes to Scharf as his ability to "laugh at the unknown" and to come:

> . . . to terms with the recognition that the
> human imagination is our greatest protection
> against doubt, and that nothing that might
> threaten us in the outside world is any match
> for what can be produced out of the inner
> recesses of the mind.

However we *are* limited to a mere representation. Put in Bubblegum terms, we are delivered to a simulacrum we can't come back from.

What is so endlessly reassuring and not a little charming about Scharf's work is that he consistently proves you can stare into the abyss and still have a life-affirming, childlike capacity for fun. In fact, Scharf insists on it. Candyman Kenny can take fellow Day-Glo celebrant Ann Magnuson out of her F-train bummer "cause he mixes it with love and makes the world taste good." Perhaps the alarmist philosophers like Baudrillard and Leonard Cohen are right when they warn us that we have been irretrievably delivered to the postmodern condition, to a Bubblegum world. I don't think there's any question we have; to speak frankly, however, it is the deadly serious, adult-minded, Dole generational whining and moaning we should have no use for. You see, there are those who choose to bemoan and those who choose to celebrate this postmodern condition, this millennial monstrosity if you will, because ultimately (and this

is the lesson of sci-fi environmentalism) we *are* those monsters. Kenny Scharf is the postmodern celebrant of apocalyptic fun par excellence. In science-fiction comic books, novels and films this is known as loving and respecting the monster—that is the ultimate lesson of Ib Melchior & Sid Pink's 1959 technologically wary *The Angry Red Planet*, the liberal sappiness of Spielberg's 1982 *E.T. The Extra-Terrestrial*, and the hippie/new age message Tim Burton self-loathingly mocks in his 1996 *Mars Attacks*.

X

From ancient worlds I come
To see what man has done
What's fact and what is fiction
To judgment contradiction . . .
Do not ignore advice
You hold the Keys of Life

"Keys of Life" (K. Nomi), 1980

Although when writing about Kenny Scharf few do more than mention in passing his relationship to German New Wave singer Klaus Nomi, I'd like to suggest Nomi is uniquely important, for he represents, along with Scharf's admiration for David Bowie and the B-52s, one of Scharf's many New Wave credentials. New Wave—with its camp aesthetic of make-up, synthesized technology, and suburban, spacey concerns—is where Scharf comes into the story: his "band" the Batusi Bros, his early B-52s groupie status, and performances as go-go dancer for Klaus Nomi. Not to mention the connection and affection so many New Wave bands have with and for Bubblegum—Blondie, the Cars, the Ramones, and the Talking Heads. What one finds summarized in the work of Klaus Nomi, crucial to contextualizing Kenny Scharf's work is a specific, late 1970s/early 1980s gay disco, apocalyptic,

KLAUS NOMI IN KENNY SCHARF'S APARTMENT. SCHARF'S "CADILLAC IN SPACE" PAINTING IN THE BACKGROUND. PHOTO BY KENNY SCHARF.

oceanic, ecstatic, androgynous, ecological environmentalism of sci-fi Bubblegum. For example, Klaus Nomi's self-introduction to us earthlings in his first song, "Keys of Life," is nearly identical to the judgment and warning of the advanced and peaceful-if-unprovoked Martians in *Angry Red Planet.*[6] The film's ecological/ethical message that Mother Mars gets disrespect from the "scientists" just the way they dis Mother Earth is clear, of course, because all futurist and sci-fi material is about us, today. But the recklessly destructive astronauts just don't get it that trees are Martians too. Try saying it in earthling language—trees are people too—and see what happens. You'll be disparaged as a throwback or new age "tree hugger." In fact, recently, Scharf unabashedly told the *Miami Herald*: "I call myself a yuppie plus hippie naturalist . . . the tree is an image that's part of my whole philosophy." It's worth remarking that probably the first popular expression of tree hugging was a positive one from Bubblegum's own Tommy James of the

Shondells in his 1970 solo hit single "Draggin' the Line," where he sings: "Lovin' the free and feelin' spirit/of huggin' a tree when you get near it." (James/King, Roulette)

Scharf's apocalyptic Bubblegum fun is designed to take us out of our bummers everywhere in everyday life—part of a street consciousness traceable back to his interest in graffiti art, although he hasn't worked with spraypaint for years now. If you want to smile, seek out his customizing of everyday objects such as telephones, mouse pads, TVs, cars. Go to the Scharf Schak vending Zippos and Swatches on NYC's Prince Street, or run across the Absolut ad in national magazines, and a reprint of his *Love is Blue* painting in the August 1996 *Playboy.* Hunt in used record stores for the *Hypnozen/ Spinshine* B-52s and Arista Dance Collection cover and vinyl art. Make the scene hanging out at the Cosmic Cavern, his signature room at the Tunnel disco on NYC's extreme west side, or sign onto his Tunnel website of interactive cyber-paintings and live remotes. When down in Florida visit the 10th Street lifeguard station he worked on at famed South Beach. Make your friends smile at the Scharf-designed tattoo inscribed in your skin. Or maybe you celebrated with me on Labor Day Weekend, 1996, on the ocean shore of the Pines, Fire Island at the DIFFA sponsored Scharf installation of inflatable Bubblegum; I mean the non-utilitarian, plastic-for-plastic's-sake lifesaver guys which carried the warning: "not to be used as a flotation device," but they work just fine as a device for fun.

1. The Monkees are the musical exemplar of this aesthetic in that they are a Bubblegum version of the Beatles, who of course are themselves Bubblegummizers of rhythm and blues. Because of their animated status, cartoon rockers the Archies and Josey and the Pussycats also superlatively state the Bubblegum case.

Bubblegum music's main manufacturer, Buddha Records, and the

"Super K" team of Jeff Katz and Jerry Kasenetz named one of their most successful bands the 1910 Fruitgum Company, and revelled no doubt in penning songs like "Yummy, Yummy, Yummy," "Chewy, Chewy," and "Goody, Goody Gumdrop." Bubblegum music begins with the sugar, and I mean any syrupy and sappy popular song from the impulse that begins maybe with the Italian operatic tenor prima donna, but is certainly there in vaudeville and rooted in New York's tin pan alley. After WWII comes the pre-rock and roll schmaltz my mother's generation was queer for: Johnny Ray, Johnny Mathis, Bobby Vinton. Surburban adolescent Bubblegum concerns show up in Chuck Berry. What is evident in the prehistorical examples of early Bubblegum is another kind of sweetness, just as schmaltzy, and that is a preponderance of gender-bending, girlish falsettos and sometimes girlish hair and dandified fashion. Rock & Roll was invented and continues to be reinvented by hairdressers. Bubblegum is present in the immediate afterbirth of rock. It's there in the silly songs of Buddy Holly: "Maybe Baby" and "Peggy Sue," Little Richard: "Tutti-Frutti" and the Brooklyn streetcorner outer-spaced tenor, uptempo doo-wop candy of Randy and the Rainbows' "Denise" and the Devotions' slacker myth "Rip Van Winkle." In the early 60s here come the apocalyptic falsettos of Franki Valli announcing the nuclear apocalypse with the siren wail of "Walk Like a Man" and "Candy Girl," and Brian Wilson's surfer-siren ("Good Vibrations" will become the most costly and classy of Bubblegum hits and closest to Scharf's pop-surreal, edge of the world California feel with its angstful Moody Blues mellotron and theremin device going the falsetto one more.), all the early Moptop Beatle singles: Ooooh-Yeah, Yeah, Yeah "She Loves You," "Please Please Me," and "I Wanna Hold Your Hand." There has always been a perceptible Beatles–Stones dichotomy and can be shown in the following schema:

European popular music/Bubblegum/artrock/Beatles/new wave/feminine

African blues/rockabilly/hard rock/Stones/punk/masculine

This is not to say that the Beatles weren't capable of rocking hard or the Stones of Bubblegumming. In fact this high 60s Bubblegum inflates during the Summer of Love with *Sgt. Pepper* and *Her Satanic Majesty's Request* and really has yet to pop. Clapton quits the Yardbirds over having to play the Bubblegum hit "For Your Love" written by Graham Gouldman, co-founder of soon to be 70s art rock/Bubblegum kings, 10cc. The god of the guitar experiments with LSD and ironically ends up forming *the* Bubblegum blues band—Cream—recording such

Bubblegum songs as "Swlabr" ("so many fantastic colors are here in a wonderland"), "Tales of Brave Ulysses" ("tiny purple fishes run laughing through your fingers"), and later doing a sweet and slick version of Bob Marley's "I Shot the Sheriff." The electric church Bubblegum anthem is the uncredited (hidden) final 89 seconds of Jimi Hendrix's *Axis: Bold As Love,* replete with Leslie phased and sonically panned drums and guitars. Do you know about his Bubblegum colorwheel project with "fiance" Monika Danneman? Consider the following explosion of Bubblegum colors: Blue Cheer, Purple Haze, Orange Marmalade, Tangerine Dream, Green Tambourine, Mellow Yellow, Frigid Pink, Crimson in Clover, Sweet Cherry Wine, and the rest. Bubblegum becomes the schmaltzy sentiment experienced through the cache of spiritually enthralling drugs like cannabis, mushrooms, LSD. A Bubblegum/"acid indigestion" (from CCR's "Ramble Tamble") is told of in George Harrison's "Savoy Truffle" and is renegotiated in Graham Parker's 1996 release "Acidic Bubblegum," replete with pink Pollock-like bubblegum cover art. Bubblegum can represent the surreal, slightly empty high and low of the trip. These drugs are all the difference and usher in a full blown, high 60s Bubblegum moment when they somehow make the scene somewhere late 1965 as beatniks morph into hippies and Bubblegum gains special recording effects, psychedelic lyrics, and after George Harrison Bubblegummized it in the west, (the sitar), where it immediately becomes musical shorthand for the presence of these spiritual enhancers. The same can be said for day-glo paint generally and Kenny's Closets specifically. Soon to seek rehab for heroin addiction and then Jesus freak B.J. Thomas made the Bubblegum/drug connection in "Hooked on a Feeling": "Lips as sweet as cherries/the taste stays on my mind/Girl you've got me thirsty/for another cup of wine./I've got it bad for you girl/but I don't need a cure/I'll just stay addicted/and hope I can endure." You might think the Archies' "Sugar, Sugar" would figure as the model of Bubblegum. While it lacks the psychedelic element and sitar instrumentation it does spring from a comicbook, in fact cartoon characters allegedly sing the song in real life! Bubblegum's alive and well in most of the purple music from the Artist Formerly Known as Prince, in the Chilli Pepper's "Aeroplane," in the pop side of Julian Cope and Beck, and above all, the abstract ear candy and cover art of the Scottish alternative group the Cocteau Twins, whose lyrics are indecipherably and gorgeously warbled by Elizabeth Fraser set to the sumptuous attack-less guitar chords of Robin Guthrie, all of which results in a concoction many critics dismiss or celebrate as "ear candy." The Cocteau Twins may very well be

going through a similar sobering phase like Kenny did during his silkscreen period as the lyrics on *Four Calendar Cafe* and *Milk and Kisses* become recognizable and reduced therefore to the yoke of the signified. Blatant Bubblegum persists as I finish this essay late 1997 in the insistently frivolous Euro-pop band Aqua who gave us the top ten hit "Barbie," followed up with "Candyman," which specifically mentions bubblegum and its accompanying video looks as if Kenny designed it himself.

2. I am thinking in particular of Oldenburg's 1975 Bubblegum confection *Alphabet/Good Humor*, monumental in size like *Globup* and dripping with soft edibleness.

3. You can hear this mannerism in the special effects of high 60s Bubblegum music. Listen to the Small Faces' *Itchycoo Park* (look for the 7" vinyl single on the hot pink Immediate label) which implores through Leslie phased drums and vocals to cut school and get high and "its all too beautiful," in the sitar drenched early singles of Traffic like the blotter-acid "Paper Sun" addressed to the young girl market, and "Hole in my Shoe," in the Young Rascals' "It's Wonderful," the outrageously long for AM Pop Radio tabla solo at the end of the Lemon Pipers' "Green Tambourine," the tremelo, delay-repeated voice of Tommy James mimicking Brian Wilson's intro to "Good Vibrations," singing "Crimson & Clover" over and over with its echoing effect much like the lysergic hiccup of "marmalade-lade-lade-lade" in "Jelly Jungle." Both effects serve as the sonic equivalent of the hallucinogenic experience of time stuttering and seeing luminescent traces. Meltzer writes: "A great deal of traditional music, such as opera and soul music, works on an intermediate stage by over-syllabicative repetition of regular words. But no one is as brazen as Lou Christie with his "Two Faces Have I-I-I-I-I-I-I-I-I-I-I-I" in his masterful portrayal of schizophrenic bisexuality. Incidentally when I played "Jelly Jungle" for Scharf in August 1996 in his studio, thirty seconds into it he asked with a huge smile "What is this?" and when I named it he said, "I love it, it's so free!" Let's not forget Jimi's feather boa, dike-daddy Dolly Dagger wah-wah pedal put to use in Bubblegum songs like "Wait Until Tomorrow" and Noel Redding's "She's So Fine" and "Little Miss Strange."

4. In the Michael Jackson video for "Black or White," a computer-assisted "morphing" process seemingly turns a man into a woman into

an Asian into an Hispanic, preventing the eye from resting on any static gender or race. And despite whatever other marketing strategies are served, a similar troubling effect occurs in a current Schick Tracer© razor-blade TV commercial where men's bathroom-mirrored faces rapidly morph from one size, shape, and identifiable race to another. This miscegenation of famous characters is reflected in the B-52s' "Song for a Future Generation" from their 1983 *Whammy* lp (contemporaneous with *Fred-o-puss Realizes*): "Wanna be the Daughter of Dracula/Wanna be the Son of Frankenstein/Let's meet and have a baby now!...Wanna be the Captain of the Enterprise/Wanna be the King of the Zulus/Let's meet and have a baby now!...Wanna be Mother–Father...Daughter–Son–Cap-tain/Wanna be Ruler–King and Empress." In the song "Kid Charlemagne" by Steely Dan the mutating is attributed to the inventor of LSD in that he "crossed the diamond with the pearl."

5. The dark and evil earlier pictorialization of this 21st century schizoid look prior to Scharf's happy, Bubblegum version is Barry Godber's cover and insert for the inaugural art rock lp *In the Court of the Crimson King.*

6. Scharf's Bubblegumby globform guys wonderfully match the film's description of the Martian monster: "It was like a huge distorted face with three bulging eyes." Incidentally, all of the Mars "location" shots for *Angry Red Planet* consist of trippy and obviously painted landscapes which look rather more like an inexpert Roger Dean than an inexpert Kenny Scharf and are all filmed in Norman Maurer's trademarked Cinemagic© which turns absolutely everything on Mars a Bubblegum pink.

CREDITS

BARRY BLINDERMAN is the director of University Galleries and an adjunct professor of art history at Illinois State University. He has curated exhibitions and edited monographs on David Wojnarowicz, Jane Dickson, Keith Haring, Alexis Rockman, Jeanne Dunning, and other contemporary artists.

ANN MAGNUSON is an actress, singer, writer, and recovering performance artist. She has performed in bands and one-woman shows in nightclubs, art spaces, and theaters across the United States as well as in Canada, Europe, and Japan. Her TV and film appearances include *Anything But Love* and *Clear and Present Danger.*

ROBERT FARRIS THOMPSON is the John Trumbull Professor of the History of Art at Yale University. He is the author of many books on African and African-American art, including *Black Gods and Kings* and *African Art in Motion,* and is a regular contributor to *Artforum* magazine.

GREGORY BOWEN is a designer, photographer, writer and the co-curator of *Kenny Scharf: When Worlds Collide.* His website (http://www.orat.ilstu.edu/cfa/galleries/cyberscharf/) examines the intersection of cyberspace and Scharf's space.

BILL MCBRIDE has published on such topics as Dracula and anti-semitism, exchangist logic in biblical poetry, and the measure-mad art of Samuel Beckett. He is a professor of drama, film and cultural theory in the English department at Illinois State University.

PHOTOS
pages 2-3, 4: Gregory Bowen; 6: Gianfranco Gorgoni

COLLECTIONS
cover: Dennis Hopper; pages 1, 36, 60: Tony Shafrazi; 14, 21, 43: courtesy of Tony Shafrazi Gallery; 28: courtesy of Totah Gallery; 39, 41, 50: Brant Foundation; 47: Guido Orso; 48: Albert Boghossian; 49: Jay Dunkelman; 57: Leo Malca; 59: Chris Hanley and Robin Rodriguez; 64: Yoko Ono; 69: Scott and Suzi Lustgarten; 70: Stedelijk Museum; 73: Laura Lee Woods; 87: Ludwig Forum für internationale Kunst; 90: Ronald Perlman; 19, 23, 55: Kenny Scharf; 8, 12, 17, 26, 31, 34, 76: private collections.

DETAILS
cover: *Zamaron*, 1990-91; 8: *Elroy and Leroy*, 1982; 28: *On the Road to the End is Near the Beginning*, 1990-91; 36: *The Jungle*, 1982; 50: *Virowow*, 1997; 70: *ObGlob*, 1987-88

THANKS
Kenny Scharf, Min and Oliver Sánchez, George Horner, Hiroko Onoda, Tony Shafrazi, Greg Calejo, Larry Warsh, Michael Blaine, Cynthia Smith

ILLINOIS STATE
UNIVERSITY